BEDLAM

ON THE

WEST VIRGINIA

RAILS

BEDLAM
ON THE
WEST VIRGINIA
RAILS

THE LAST TRAIN BANDIT TELLS HIS TRUE TALE

WILSON CASEY

THE
History
PRESS

Published by The History Press
Charleston, SC 29403
www.historypress.net

Copyright © 2015 by Wilson Casey
All rights reserved

First published 2015

Manufactured in the United States

ISBN 978.1.62619.893.7

Library of Congress Control Number: 2014958800

To my daughter, Colleen Adaire Casey,
the possessor of great fortitude…you are my heart.

Contents

Preface

He never meant to rob a moving train.

His name was Luman Ramsdell—"Lu" for short. He lived eighty-six years, died in 2012 and was only twenty-three at the time of the train robbery. He grew up in Youngstown, Ohio—a "Little Chicago," he called it. His father died when he was two. His mother loved him unconditionally. He never grew up worrying about his future. Lu had no brothers to worship or sisters to tolerate.

In 1949, as former convicts, he and a fellow bandit boarded the Ambassador, a Baltimore & Ohio (B&O) passenger train heading from Washington, D.C., to Detroit. The 2-man gang (although other accounts thought it was more like 4 to 6 bandits) took over the train and terrorized 147 passengers and crew as it left Martinsburg, West Virginia. The armed robberies, massive manhunt and police shootout shocked our nation. The events were readily compared to Jesse James's capers of the Wild West in the 1870s. It was national headline news. It really happened.

The first time I saw Lu in the present day (2009), I said to myself, "Boy, that's one weird character." A first impression he did not make—certainly not a good one. His shoulder-length silver hair, matched with an unkempt white beard, aroused a certain eeriness. A rowdy moustache was lost inside his teeming facial hair. He was dressed in dark clothing, with a six-foot frame not humped down from years of wear and tear; instead, his good posture

resembled that of a person many decades younger. He wore a dark Trento Borsalino, a five-point ivy cap with a sewn bill.

As a professional entertainer and speaker, I compile a daily trivia column for numerous nationwide newspapers. Being labeled the "Trivia Guy," I provide emceeing fun and upbeat entertainment for many varied groups, civic organizations, churches, pubs and conventions—anywhere there's an eager audience. I mainly play trivia with them. During these times, curiosity seekers are always coming up to me asking trivia questions, probing thoughts and "whys." It's a common routine before, during and after my engagements. The folks are inquisitive and simply want to know more about such and such that I asked or talked about. That continual public interaction keeps my crafted skills honed. I enjoy what I do. My act enthuses audience members and shows that I'm personable. I do get to meet a lot of smart, interesting people.

I'm good at noticing faces in the crowd, especially reoccurring ones who follow my gigs. Lu always seemed to be in the background, loping around in the audience. He was a loner among the other patrons, but at breaks or after my sets, he'd often approach me. That's how I first met him. It was usually when I was packing up speakers, cords and equipment. He was persistent, gig after gig. He'd keep asking me the same question: "Who was America's last moving train robber?"

Again, while emceeing various trivia functions, I've gotten used to people coming up to me asking trivia questions, but Lu kept asking me the same question over and over. That went on for several weeks. I kept giving him the same answer: "It was Jesse James or Butch Cassidy—that's what the history books say." I didn't brush him off, nor was I rude to him, but I was seriously wondering why he was fixated on that same topic. Why in the world does he keep asking me this?

One particular time, I had a reading at a local writer's project, and there was Lu again. He was seated in the audience about twenty feet from the podium. After my presentation and as I was leaving the stage, he approached me with that same question: "Who was America's last moving train robber?" There was no small talk from him. He'd get straight to the point, and from my research and trained memory, I again gave him the same answer: "Jesse James and his gang or possibly Butch Cassidy." I was accustomed to him warmly smirking and walking away, but this time it was different. He didn't walk away. He stayed right with me, in front of me. Lu calmly said, "No, it wasn't."

"What?" I questioned.

He stated sincerely and reverently, "No, it wasn't." Then a short pause as he made stronger, more direct eye contact. "It was me." His look was deep and penetrating. His tone of voice was sincere. Five seconds passed.

I said, "What?" A quiet hush came over me. I wrinkled my brow. I frowned out of the right corner of my mouth. I looked into his eyes. I was trying to stare him down.

Again he said, "It was me."

It was a profoundly unsettling experience. I thought to myself, *What can he be talking about? Who's he kidding? Why does he keep asking me that same question over and over? Does he suffer from Alzheimer's? Does he realize his repetitiveness?* This time, I was ready to pursue. I wanted to put closure to his persistence. *I had answered his question; he's very old and just mixed up. I should be nice to him and move on.* He didn't move away, nor did I.

Lu was carrying a stuffed bag with him. It was an old makeshift sack with cloth handles. Then he started reaching in and pulling out papers, some wrinkled, some folded. It was a thick 3- to 4-inch collection of photocopied clippings, some larger than the standard 8½ by 11. He handed me some. I took a number of them in both hands and started opening them up. I quickly started perusing. In astonishment, I was raising my brows and widening my eyes.

From Lu's collection of newspapers I was seeing headline after headline— "Train Robbery"…"Jesse James–like Bandits"…"Mugging Passengers"… "People Robbed"…"Stealing Getaway Cars"…"Massive Manhunt"… "Shootout with Police"…"Last Rites"…"5 Blocks from White House," etc.

I was frozen in disbelief! To my utter surprise, he had handed me flamboyant national headlines and articles from 1949 newspapers. They all featured this B&O train robbery. It was national news! I was still dazed in that he had just told me it was him who pulled off the robbery. This guy was the mastermind, the leader, the notorious criminal, the man who stopped and robbed a moving train. Here I am in conversation not three feet from the 1949 head bandit *himself.*

Trying to gather my coolness, I questioned Lu again, "What?…How can all this be about you?" He never answered. He was too busy pulling out more and more photocopied clippings from his bag. Thinking again to myself, *Could this have happened? Is this the guy? Why is he telling me?*

I steadily gazed at the headlines of more of the papers he presented. They were from newspapers all across the country. He had a dozen or so photocopies with him. Paper after paper, all talking about the same shocking story, even the 1949 *Spartanburg Journal* newspaper of South Carolina, where

Lu and I both now lived. I was still flabbergasted. That part was OK. It was so wild in my mind. My inner thoughts and further questions began racing. *How could the historians have missed this? I'm a professional researcher. I thought it was Jesse James and his gang or possibly Butch Cassidy who stopped and robbed the last moving train in America—certainly not Lu and his gang.*

All that Jesse James and Butch Cassidy info, as well as the myths and folklore, was now being proven wrong before my very eyes. The history books were in error. It wasn't Jesse or Butch. Lu was America's last moving train robber. Finally realizing that Lu was on the level and truthful, my thoughts were settling down and becoming more orderly.

Here I am face to face with the head bandit himself in the year 2009. He stopped and robbed a moving train with 150 passengers. How could he still be alive? Why isn't he in jail? How has he survived so long with such a background? And why is he living in Spartanburg, South Carolina, of all places? That's where I also reside. Is he still dangerous? Is he a menace to society? This is the guy I'd been politely brushing off for months. Is he angry at me? Is this the guy who stopped and robbed a moving train with 150 passengers? You've got to be kidding me. How can this be? I'm not dreaming. I'm not watching a movie.

As I came to know him, none of my irreverent thoughts ever panned out about the main character. Lu was a gentle man who honestly wanted me to tell his story. He chose me. He believed in me. He knew from my other books that I fought for the little guy when it came to getting things correct. The notorious train robber had chosen me to be the intimate insider of conveying exactly what happened many years ago in 1949.

Train robberies were more common in the nineteenth century than in the twentieth. They often occurred in the American Old West with guns a-blazing. Trains that carried payroll shipments were major targets of bandits. Many of the outlaws were organized, but others would make robbery attempts on the spur of the moment, usually while intoxicated. The bandits' first goal was to steal any money being delivered as cargo. Those shipments would be guarded by an "expressman." His duty was to protect the cargo of the "express car." These expressmen, conductors and other train personnel took enormous pride in their duty. They had no problem risking their lives for a shipment or protecting the safety of passengers.

If the outlaws of the nineteenth century were able to overpower the expressmen, they'd take what valuables they could and then flee the scene on horseback. But if the bandits were unsatisfied with the goods, or if they couldn't get into a safe or the train's strongbox, the passengers would be held up at gunpoint. Sometimes both scenarios took place. These travelers in the train carriages were usually unarmed. They would be forced to hand over any valuables they were carrying, usually in the form of jewelry, watches or currency. It was commonplace for uncooperative passengers to be pistol-whipped into submission. At times, passengers were shot, knifed or bludgeoned. That made a serious point with the other travelers. If the person in front of you was being terrorized, you'd certainly want to cooperate to the fullest when the bandits got to you. The robbers would go up and down the aisles, looting the passengers at will. This is exactly what Lu and his "gang" ("Duke" was his cohort) did. They were a gang of two.

I was soon to become involved in the life of the main character and subject matter yet able to observe from a somewhat detached vantage point. I'd have the complete detail firsthand and wouldn't be blinded by the groupthink of those 1949 newspapers. Their references to the days of Jesse James were many and frequent, as officials and reporters pieced together the brazen, gun-slinging train robbery, shootout and ultimate capture. Writing about Lu and his gang, they had all the trappings and descriptions of the frontier days. It was insightful and meaningful to collect Lu's firsthand accounts. Later, during my passionate research, I was able to uncover more than fifty such articles accounting the train robbery and even a comic strip. There was very little, if anything, on the Internet. Digging through microfilms at my local Spartanburg, South Carolina County Public Library proved invaluable.

Thus, being permitted to position myself alongside the genius mastermind of Luman Ramsdell, to spend time with him the last three years of his life and hear his story, captivated me. He was a real-life person, a real-life train robber and a real-life "thug" who became my friend. Lu was a career criminal until late in life, and his quick wits and narrow escapes followed him. He allowed me to hear the inside story during our private meetings and interviews, right up until his death at eighty-six in 2012. I could not help but become submerged into his life's past and infamous path of criminal activities.

My in-depth dealings with this train robber led to my intensive research on the central character and much time spent with him. We'd meet for breakfast a few times a week at the local Hardee's, a fast-food restaurant near the house where Lu was living. He was a stamp collector. He also asked

me to speak at one of his club's monthly meetings. I picked him up, and we rode to the affair together. None of its twenty members present knew about or even suspected the truth of Lu's past. He fit right in. It was an intellectual group. With my Guinness World Record–holding credentials, I entertained them via my trivia fun. I was able to stimulate them in an entertaining but informative way. I sensed that they all respected Lu for what he was with them—a notable intellectual with sharp wits.

The Trento Borsalino caps in different colors would become part of his everyday appearance during the many times we would meet for breakfast conversation at the Hardee's, a busy place in the mornings. Lu drove himself there. We both loved the gravy biscuits and coffee. I taped many of our talks with a microcassette recorder and was always jotting on my notepad. Lu was good about drawing and doodling illustrations to clarify my many curiosities. Sometimes we would sit and talk in the restaurant's parking lot in my Jeep Grand Cherokee. Doing that provided further privacy. It cut out the background noise of when we were seated inside the restaurant trying to talk.

This was the beginning of a fascinating journey of actually being able to talk live with a formerly extremely notorious human being—the man who was there during all the mayhem and dangerous escapades. He was the gang leader. I came to know Lu like growing a soul. He became my friend. After spending countless hours with him, I wanted to tell his story—the true account behind "America's last moving train robber." I want to set the history books straight.

The firsthand account takes place in 1949 near Martinsburg, West Virginia.

Enjoy the ride!

Acknowledgements

Whenever there is a roll call of ones who made such a work possible, there are always those who are inadvertently left out. I apologize for that and will always cherish their hospitality, wise counsel and friendship. But to the ones listed (and to any left out), I can only reciprocate but never repay. However, I do wish to sincerely thank certain persons and all the various press mediums that contributed to my work.

First and foremost, Mr. Luman Ramsdell, the head bandit and train robber, who allowed me to hear his story during our many meetings and interviews the last three years of his life. J. Banks Smither, commissioning editor, and Ryan Finn, project editor, at The History Press. Rita Rosenkranz, my literary agent and business partner. S. Deane Brown, for providing photography assistance throughout and cover conception. Connie Hollar, for motivational inspiration to complete project. Gerald Cooperman, for research and archival support. Colleen Casey, for editing and proofreading assistance. Dr. Deno Trakas, my writing career mentor. Thomas E. Foster, retired judge and legal advisor. For community comments on Lu (Lou), I thank Tony Brooks, S. Deane Brown, Phil Cannon, Colleen Casey, Connie Hollar, Kelli Cannon Lanford, Ann Patterson, Bruton Redding, Bob Sutherland and Patty Wright.

Death Notice for Luman Ramsdell

By Lee G. Healy, courtesy of Spartanburg *(SC)* Herald-Journal, *September 30, 2012.*

A Quiet Passing Marks Life of Celebrated Train Robber
1949 Train Heist Front Page News Across U.S.

Luman Ramsdell frequently sat on his front porch at his Spartanburg, SC home, where he'd watch the squirrels and neighborhood cats. One of his paintings hangs behind him on his porch.

A one-sentence obituary quietly marked the death last Sunday (09-23-12) of 86-year-old Spartanburg resident Luman C. "Lu" Ramsdell.

But in 1949, he was headline news across the country. Ramsdell was a train robber, compared to notorious Wild West outlaws like Jesse James.

At just 23 years old, Ramsdell and an accomplice brazenly robbed a Baltimore and Ohio passenger train on the night of March 9, 1949, as it left Martinsburg, W.Va. He was cornered and nearly fatally shot by police the next day in a Washington, D.C. pawnshop just blocks from the White House.

Ramsdell liked to say he turned his life around while serving a federal prison sentence, but he was never shy about telling the tale of the famous train robbery—an exciting chapter in his life story. According to those who knew him, Ramsdell moved to Spartanburg a decade—or two—ago. Many pieces of his personal timeline are more approximations or educated assumptions than known facts.

Friends do know he was opinionated. Proud. Intensely creative. He had stories to tell. If you asked him, Ramsdell might have called himself a commercial artist. He might have also called himself a train robber. Patty Wright, who helped care for Ramsdell in the last years of his life, said he wasn't ashamed of his past. He almost seemed to enjoy luring people in with the blunt, honest proclamation: "I'm a train robber." Wright was immediately fascinated by Ramsdell. She met him while delivering for Mobile Meals and was stunned to be greeted at the door by an elderly man in a white robe and a shock of long, white hair with matching beard. "He looked like ZZ Top," Wright laughed.

The two shared a love of art. Wright is a photographer. Ramsdell, a painter, cartoonist, illustrator and jack of all trades. "He was very creative," Wright said.

Paintings hung throughout his Beverly Road home, located not far from Mary Black Memorial Hospital. A canvas of painted red flowers decorated the porch where Ramsdell often sat to watch the world go by. Next door was Ann Patterson, a copy editor for the *Herald-Journal*. Ramsdell was living in his home when Patterson moved onto the street in 2000. She described him as quiet, thoughtful and observant. Ramsdell's criminal past came up one day during a casual conversation, Patterson said. He never made a big deal of it. "He was always very nice to me," she said. "He didn't have the demeanor of a man who was a criminal. He had the demeanor of an artist instead." Patterson said her neighbor liked to watch the squirrels and neighborhood cats from his porch. He kept a keen eye out for sales on art supplies. Painting, she said, was his passion.

According to Wright, Ramsdell taught himself about art while serving a federal prison sentence in Atlanta. He saw it as a turning point in his life—a way to be a productive member of society. Still, she said he was never ashamed to talk about the acts that landed him behind bars.

Ramsdell shared the story in detail with Wilson Casey, an author and trivia columnist for various newspapers, including the *Herald-Journal*. Casey was working with Ramsdell to write a book about his life, tentatively titled "Bedlam on the Rails: The True Story of America's Last Train Robber." "No matter

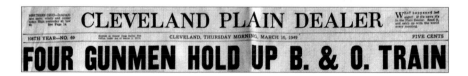

Courtesy of the Cleveland Plain Dealer.

how wild it seemed, I could always corroborate it with newspaper articles," Casey said of Ramsdell's stories. Casey said Ramsdell admitted to entering the criminal world early, robbing supermarkets as a teenager. To straighten up, Ramsdell joined the Marines and served during World War II. Casey said he was a decorated serviceman, and some newspaper clippings refer to him fighting on the beaches of Okinawa. Once home again in Ohio, Casey said that Ramsdell slipped back into trouble.

According to various newspaper accounts from the time, Ramsdell and his partner, 20-year-old George "Duke" Ashton, were on their way home to Youngstown, Ohio after a trip to Miami when they boarded the B&O Ambassador train. Nearly 150 passengers were on board. Casey said that Ramsdell insisted he and Ashton never intended to rob the train, but an argument over drinks in the club car escalated and guns were eventually drawn.

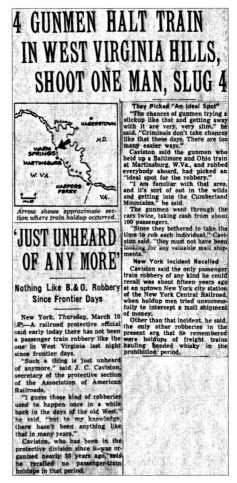

"Whiskey was his drink of choice," Casey said. As the two made their way through the train, they roughed up passengers who put up a fight. One man's leg was reportedly grazed by a bullet.

An Associated Press article from March 11, 1949, makes reference to an elderly Maryland woman named Alice Miller, who was slapped by one of the men because she tried to hide her purse. "In spite of the slap, she saved her money," the article reads.

"They got what they could," Casey said, recounting Ramsdell's tale. "Cash, furs. It was whatever they could carry."

The pair forced the engineers to back up the train to the last crossing, where they hopped off

Courtesy of the Baltimore Morning Sun.

and made their escape. Reports of how much they took vary. Some papers say about $500, while others report $1,500. Ramsdell and Ashton eluded authorities for several hours. By some accounts, they held up a tavern before stealing a car and eventually hopping a bus to the nation's capital. A tip led police to S&W Pawnbrokers on Pennsylvania Avenue. Ramsdell drew a gun but was shot by an officer. Ashton surrendered.

Headlines about the robbery were splashed across front pages from Florida to Maryland to South Carolina and beyond. The *Spartanburg Journal's*

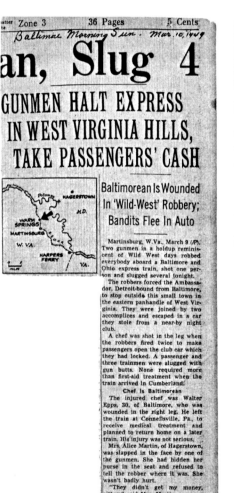

Courtesy of the Baltimore Morning Sun.

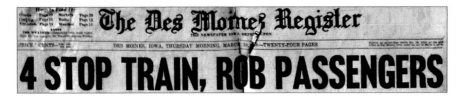

Courtesy of the Des Moines Register.

March 10, 1949, bold headline read "Police Capture Train Robbers After Battle." Photographs of Ramsdell recovering in a hospital bed and Ashton in police custody ran on the front page of the pair's hometown newspaper, The *Youngstown Vindicator*, on March 11, 1949. Both men got the maximum sentence of 20 years in prison, according to various news clippings, although Casey said Ramsdell only served about seven.

"He made some mistakes," Casey said. "But was he remorseful? Not a bit." Wright said that Ramsdell would want to be remembered more for the direction his life took after his prison sentence than his role in the famous train heist.

"He did not want to lean on him being a train robber. He wanted to lean on: You can be a bad person; you can rob a train and go to jail; and you can become reformed," Wright said. "He lived the rest of his life as a good citizen."

Ramsdell lived a relatively quiet life in Spartanburg. Casey said he spent hours with Ramsdell at his favorite hang-out—Hardee's.

"He loved gravy biscuits and coffee," Casey said. Ramsdell lived in the Atlanta, Ga. area for several years before moving to Spartanburg. He was a long-time member of the Spartanburg Stamp Club. Secretary Carroll Gilbert said that Ramsdell specialized in air mail stamps. Gilbert described him as "a little secretive" but "interesting." In the 15 or so years Gilbert knew him, Ramsdell never disclosed anything about the train robbery, but told him about his family—a son serving in the Air Force—and his time in the military.

Wright said that friends and family are planning a military service for Ramsdell. His ashes will be buried in the National Cemetery in Canton, Ga.

CHAPTER 1

Troubled Youth and Military Days

One would be crazy to rob a bank.
—Luman Ramsdell

As I watch crime thrillers on TV and in movies, it intrigues me to imagine that some are based on actual happenings. I've learned that only energy, tact and "brass balls" are giving life to the ill-gained temporary footing of the criminals portrayed.

My times spent with Lu were not a form of hero worship but more of fascination and intrigue. This fascination grew as I kept meeting and talking with him. No matter how far-fetched the things he would tell me were, I was always able to corroborate them with newspaper articles and through extensive research about him. At first, I was in stubborn disbelief and kept telling myself that this couldn't have happened. But the criminal activities did. Everything he was telling me really occurred. I was hearing firsthand, straight from the horse's mouth. It was one seemingly wild tale after another. Lu filled my heart and soul with his life's story. And everything he was telling me was the truth. All his criminal-related activities had actually been experienced through his eyes and life as a "thug."

Lu was a tall, handsome teenager from a nice family in Youngstown, Ohio. He committed his first crime at age twelve when he swiped a pack of cigarettes from the local supermarket. He didn't get caught but loved and remembered the electrifying rush of excitement when he stole. That, combined with a hatred of any authority figure, caused him to decide to take up his life of crime. He quit school, left home and formed a teenage gang.

As a youth, he stayed in trouble. His hometown area was like a "Little Chicago," filled with widespread corruption. Lu rebelled against all authority. If he came upon a vehicle running without someone in it, he would hop in and take it for a joyride. He'd steal it for the kicks. It was wrong, but he'd take someone else's car. It was Lu's way of mischief and fun. That was commonplace for him while growing up in the late 1930s and 1940s. People routinely left their vehicles running as they went into stores to pick up items. They were afraid that if they turned their car off, it wouldn't start back up. After numerous successes of stealing cars, he started selling them. The local "fence" could quickly get them out of state, so it was an easy method to generate fast cash for Lu and his teenage cohorts. (A "fence" is a middleman between thieves and eventual buyers who knowingly purchases stolen property for later resale.) The gang could make fifty bucks per car, sometimes more. It relied on Lu as its leader.

Lu stole about a dozen vehicles during his teenager crime spree years and routinely got brought in for questioning by the local coppers. Lu loved calling them "coppers" even to their faces. Although he never got caught initially in the act of stealing a car, he still kept getting locked up, brought in and arrested on suspicion. His jail-serving stints were usually a weekend or a week, with a few months in reform school. He was technically still a minor. He hadn't reached his eighteenth birthday yet.

Still, as a teen, he took a part-time legit job at a Youngstown car dealership and was asked to go to New York City and drive a car transporter truck to bring back several vehicles. The job went fine, and Lu was gone about a week; as always, upon returning from various escapades, he would go by his mother's house. She was tired of not knowing where he was or where he had been. This time, it really upset her for him to not tell her that he'd be out of town for a few days. She wouldn't let him in the house. Determined to get into the house, he went around to the side to a coal chute. He entered the house that way and got into the basement. His mother called the police on him. Lu's own mother had him locked up.

That weekend, while spending time in the local lockup, he befriended a local crime kingpin, twenty-five years his senior, who was in the cell next to him. Instead of being fed less than desirable jail food, Lu was eating steaks compliments of his new friend. The good food was being brought in from the outside as the local jailers or guards looked the other way. That friendship stayed in place; later down Lu's criminal life, that same "friend" helped arrange Lu a female lawyer who would help him avoid a lifetime of imprisonment. Lu stayed "connected" his entire criminal life. He remained

that way right up until his demise at a hospice house facility in Spartanburg, South Carolina.

Lu never robbed a bank. He said that one would have to be crazy to try such a thing—security, guards, too much of a risk. He idolized John Dillinger, but he was not like Dillinger in that he really didn't want to hurt anyone unless he absolutely had to. Lu always gave his victims options—"Do what I say or else." Bullying and intimidation were his answers for getting people to do what he wanted. That, with a belly full of whiskey, worked for Lu. He loved to party, and he loved women. He had five wives. The first four were white and the last one black. Lu married the black woman to upset society's normal thinking. He loved her and didn't care what others thought. It was one of his ways of making others think he was a big shot and above everyone else.

In the 1940s, times were tough. Lu said that his grandmother had an old clunker of a vehicle that would break down in their driveway, even when it wasn't running—that was Lu's dry-witted humor.

As a teenager, Lu always had money, usually stolen money. Lu, with his friends and teenage gang of five, regularly stole vehicles. They also robbed and terrorized markets or grocery stores on late Saturday afternoons. They used simple disguises, such as bandanas or handkerchiefs pulled up over their mouth and noses, much like outlaws robbing a stagecoach in the Old West. The stores were small operations located three to four blocks apart. They were mom and pop stores with only two to four employees. Lu and his teenage followers pondered, but they never tried to rob more than one grocery store on any given Saturday. They didn't want to push their luck. They thought they were invincible.

Families would come to town on Saturdays to buy their groceries for the week, many for the whole month. Grocery stores were bulging with cash on Saturdays, with really no security to speak of. Most of Lu's grocery store robberies went off without any weapon, except maybe an occasional knife. The courage and gall, helped by whiskey-sparking intimidation, were all that were needed. They were in and out in three minutes or less to pull off their successful robberies. Most of the stores only had one cash register. The gang's usual method was to burst in and quickly and recklessly push and slug innocent customers to the floor. They'd be yelling, "We're robbing the place! Do as we say! Or else!"

While slinging the cashier who was behind the register out of the way, they'd reach in and grab as much paper money as their hands could clutch. Many times, upon running out, they'd unintentionally drop loose bills on

the floor. They didn't take in sacks for the money, as Lu thought this would take too much time to try to put money into them. They were accustomed to their quick snatch, grab and flee. There was no getaway car waiting on them out front. The teenagers would get away on foot, often dodging in and out of alleys to meet at a determined secluded spot not too far from the robbery spot. Lu would divide up the loot, always keeping more for himself. He deserved it for masterminding the caper. He was the ringleader.

After five to six such robberies in the same area, often the same store twice, the store owners started arming themselves, mainly with pistols and shotguns. It was becoming more dangerous and a higher risk for the thugs, as well as the innocent shoppers who could get caught in the crossfire.

One such robbery attempt went south. The store owner was armed. Lu knew that they were in trouble when the owner pulled out a pistol. Lu, who was not armed but heavily intoxicated, boldly stared down the pistol-yielding owner. Lu was only sixteen at the time but somehow knew the guy couldn't pull the trigger. Lu walked right up to him, wrestled the gun from his hand and slugged him up side the head with it. Dazed and frightened for his life, the owner lay on the floor, expecting to be shot. Lu didn't fire. Instead, he motioned for him to get up. The owner's wife and an employee helped him to his feet. Lu ordered them into the meat locker, waving his newly acquired pistol. He barricaded them in and left them in the freezer as he went back to emptying the cash register of the small establishment. By this time, the handful of customers who had been shopping had fled. The store was empty.

The next day, Lu heard on the radio that three people had frozen to death. He felt horrified at the thought that it was them. It turns out that it wasn't. Instead, it was three homeless souls in the area. Lu was so relieved that he hadn't killed those three people he had left locked in the meat locker. Lu's innate lack of fear of a pistol that was pointed at him and ready to be fired would come into play a few years later in his life, when he was confronted by the Metropolitan Police only five blocks from the White House. Lu looked into the store owner's eyes and quickly determined that he couldn't pull the trigger on another human being. Lu had gambled with his life and won.

During an unrelated incident, Lu went out drinking in one of the area's fancier hotels. It had a small bar and was packed with about twenty out-of-towners. Alcoholic drinks were being served in waves to help keep up with the eager, thirsty customers. Lu noticed that when the waitress would come around to settle bar tabs, the drinkers would say to please charge it to

such-and-such room number. The youthful criminal figured out how easy it was to settle tabs.

Lu, who always loved the idea of the big shot appearance he tried to maintain, ordered a round of drinks for the entire room. That request was fulfilled quickly. Then Lu did it again! Another round for everyone! The waitress made her way to Lu to pay for the somewhat large tab. Lu told her to charge it to his room, as he had made up a fictitious room number. It worked! The waitress accepted his request. Lu finished his drink and left. He was not staying at that hotel anyway and did not frequent that same establishment ever again.

Lu was becoming a regular to appear before the local judge. Although a minor under the age of eighteen, he was a repeat offender. He was continually suspected for "thug" crimes in the area. Lu's jail time amounted to very little even though his rap sheet was growing. He kept getting bailed out by his teenage buddies, who kept using the stolen money from grocery store robberies and the fenced cars. The crime kingpin whom Lu had met earlier during a lockup never bailed Lu out, but he was keeping tabs on things from a distance. He was building respect for the loyalty that Lu maintained with his buddies. Lu was not a rat or a snitch, and neither were any of his teenage criminal cohorts. Lu's power and respect among the thugs he hung out with were growing every time he got out of jail.

Although suspected, he was never officially charged for his string of grocery store robberies. He was lucky that he never got caught, and that no one was ever seriously injured, during those capers. Lu never appeared before a judge for those crimes. His court appearances as a youth were limited to carjackings and unlawful joyrides. The first two times, the cars were returned undamaged. He'd joyride and then leave them parked on the side of the road. The next three were sold to the fence for quick cash.

The final and sixth time he went before the local judge, it was different. There would be no bail. The judge leaned on his bench and glared down at the seventeen-year-old kid standing before him. He had tried to rehabilitate Lu in earlier court appearances by trying to scare him. This time, Lu had struck a guy with a club when he attempted to steal his car. The guy was not badly hurt, as a copper cruising the neighborhood saw it going down and quickly thwarted the robbery attempt. Lu was arrested after surrendering peacefully.

The judge was furious. He had tried to give Lu a break and to get some help for him each time on previous appearances. Nothing had worked. Lu was incorrigible, defiant and remorseless. This time, Lu's thievery included

assault with a deadly weapon. The judge shook his head in disgust and was pondering a twenty-year sentence. He didn't like the thought of sending a seventeen-year-old kid to prison long term with hardened inmates. The judge sighed and leaned back in his chair. Lu stood silently with his head bowed. He knew that it was very serious this time. Now appearing before the judge a sixth time, his only regret was that he had been stupid enough to get caught. (At the time of this court proceeding, the United States was fighting in World War II.)

Unable to arrive at a quick decision, the judge called the public defender and solicitor to the bench (this was years before Lu would have a phenomenal attorney to defend his train robbing spree). "I don't know what sentence I ought to hand out. Ramsdell really should serve some hard time and I'm allowed by statute to give him up to twenty years. I had earlier hoped to rehabilitate him. I put him in a reform school three separate times, the longest being six months. That didn't help. I've fined him. I've locked him up in short bursts. He's just a hardened thug who needs to be put away from society," the judge declared. (If the judge had known about all the grocery store robberies, Lu would have been put away for life.)

The public defender pleaded, "Judge, let's be merciful one more time. How's this for a just answer? All of America's armed forces are looking for men to fight the Japs and Nazis. If my client was willing to join up, wouldn't that solve our problem? Either jail or join? I'm thinking a drill sergeant could knock some sense into him." The solicitor did not voice an opinion either way.

The judge said, "OK, let's pose it to Ramsdell!" The public defender and the solicitor returned to their station. The public defender whispered to Lu and advised him to fight for his country rather than rot in jail.

The judge sternly said, "Ramsdell, look me in the eye. The sentencing of this court is giving you a choice. Have you the guts to fight for your country or would you rather be housed at hard labor in a cell for twenty years? Maybe fighting the Japs or Nazis would beat some sense into your head and make you a decent human being. How 'bout it? It's solely up to you, and this court needs your decision now. War or jail?" Lu looked down. He wasn't crying, but he was tearful. He mumbled his answer. "Speak up, war or jail?" the judge exclaimed.

Lu looked up. "You must want me dead, your honor. A fast one on the front or a slow one in the yard."

"The court is awaiting your answer, Mr. Ramsdell," protested the judge.

A strained look of contempt distorted Lu's face as he spit out his answer. "War, judge! I want to be a Marine and go to war!" The defendant had made his decision.

Lu would go on to serve on three suicide squads of seven members each in the war islands of the Pacific. During one such mission, he was the only one to return. In 1945, Lu was discharged at age nineteen from the U.S. Marine Corps. He had been evacuated by airplane after the fierce Battle of Okinawa. His killer training of "shoot anything that moved" did not qualify him for any regular civilian professions. He did earn a 50 percent disability for battle fatigue (psychoneurosis hysteria) and for his superficial head and knee wounds. Lu's heroism and wounds earned him the honor of receiving a Purple Heart.

Lu returned home somewhat of a war hero, but he still held a vengeful vendetta against authority.

He knew he wouldn't fit in!

CHAPTER 2

Crooked Horse Betting

That damn midget jockey, I'm still looking for him.
—Luman Ramsdell

After returning home from fighting in World War II, one of Lu's Veterans Administration (VA) assisted jobs had him selling women's corsets and bras in a large discount store. Lu described it with a sarcastic, "Whoopee!"

Lu kept his nose pretty clean the following three years or so. Perhaps the military had straightened him out from his criminal thoughts and activities. He had fought and killed others in the name of his country. He had stayed alive on suicide squads. Lu had become even more hardened and was well versed in weaponry and survival. The military had taught him a lot about many things. He had endured Japanese bullets whizzing by him. He learned to kill or be killed. He was thankful to return home alive.

After being back a while in Youngstown, he would meet George "Duke" Ashton. Duke was three years younger than Lu and had had a rough life himself, hinging on borderline law breaking and petty crimes. The two had grown up in the same area, but they didn't meet until they ran across each other in a bar one day. Lu couldn't remember the first time he met Duke Ashton, but they instantly became friends. The two would soon become very close buddies and would hang out together most every day.

Lu soon found an opportunity to make some money in Florida. He asked Duke to come along. Both jumped at the chance to make some money

and leave home. Besides, it was also a nice time to escape a harsher, colder Youngstown, Ohio climate to go to a sunny, warm Florida.

The two were sent to Coral Gables, Florida, to "bet" on fixed horse races through Lu's alliance with a local criminal kingpin in Youngstown. (Coral Gables is located just outside Miami.) It was the same person and connection Lu had kept in touch with from years earlier, when they had met in adjourning jail cells during one of Lu's lockups as a teenager. The kingpin trusted Lu, and Lu trusted him.

It was late February 1949, and by this time, Lu was twenty-three. His buddy Duke was twenty. Lu was the leader. Duke followed him and did as he said. They were both now army vets. (Duke never saw actual fighting in World War II due to a hearing problem in one ear, although the affliction was not too serious.)

The kingpin financed the Florida trip from Ohio and arranged Lu and Duke transportation to get there. A third gentleman drove Lu and Duke to Coral Gables. He did not stay or wait on them. The driver immediately left to return to Youngstown. After their horse-betting business was conducted, Lu and Duke were to catch a bus or train back home. The kingpin had loaded them up with a satchel of cash to place bets for him at the racetracks.

I kept prodding Lu for the kingpin's name. He never indulged me; I guess it was an honor among thieves not to tell. My research never uncovered the kingpin's name, either. Maybe it wasn't that Lu didn't want to tell me, but rather he couldn't recall his name from more than sixty years earlier. Or perhaps it was part of the unwritten code to never reveal names.

Later, false newspaper reports said that third gentleman from Ohio was a part of the train robbing gang. That third gentleman had driven Lu and Duke to Florida in his car and then tried to return to Ohio. The driver, though, was not in on the train robbery. False reports noted that he was supposed to meet the train bandits out of Martinsburg, West Virginia, to help further their getaway. The driver was questioned by the police; he denied bringing the two back, stating that his vehicle had broken down on the return trip. Lu made it clear that that driver had nothing to do with the train robbery. He was just a drinking buddy helping Lu and Duke out by driving them to Florida.

In Miami, there was a crooked jockey "on the take" whom Lu and Duke were to meet up with. Upon arriving in Coral Gables, they checked in and got settled into a second-floor room at a hotel close to the tracks of

Tropical Park. The room was basic—not too fancy but functional. The toilet and bathtub were down the hall. There was no shower. There was no air conditioning. Radiator heat was used to warm their room.

Although it was late February, Coral Gables in southern Florida was not very cold. They raised the window to get some air stirring and unpacked their bags. They were anticipating a nonstop party for the next few weeks during their stay. A time for whiskey, women and gambling.

An hour after checking in, Lu went down to the lobby to use the phone. There was no phone in their hotel room. He left a message for the jockey at a phone number that was supplied to him when he and Duke left Youngstown. The jockey called back within an hour or so as Lu was hanging out around the lobby phone. Duke was napping in the room. Lu told the jockey the hotel room number and invited him over for a drink and some talk. The jockey came over in less than thirty minutes, as he was nearby at the track that was close to the hotel.

The jockey was a small man in his mid-thirties at five feet tall, weighing about 120 pounds and slightly balding. Lu quickly found out that the jockey not only rode horses in various races himself but also had insider knowledge on most all the other horses and jockeys. He soon told Lu and Duke exactly how to place their bets over the next several days. They were looking forward to winning a bunch of money. In his conversation with the jockey, Lu summed it up to himself that there were several other jockeys also on the take—more crooked ones than honest ones.

The races were daily. It seemed that no matter what time anyone got to the track, there were races going on. The hotel in which Lu and Duke were staying was so close to the track that they could walk over to it, less than a fourth of a mile away.

The plan was simple. The jockey would meet up in the hotel room every night and provide instructions on how to bet the following day. Lu and Duke would get a small cut of the winnings but with all their expenses taken care of, including the hotel room, food and booze. Lu was writing everything down on a small pad he kept in his pocket. He did this on his own. It wasn't for the kingpin. Lu liked to keep up with things, except for his occasional drunken blackouts when he couldn't remember things clearly. Lu did drink heavily. Jotting things down on his notepad helped.

It was always party time while in Coral Gables—boozing, betting and playing the role of a big shot. Lu loved the thought of others thinking that of him. He and Duke were eager to do some womanizing, too. Whiskey was always flowing freely.

Courtesy of the author.

During the second meeting, Lu asked the jockey about his cut of any of the winnings. He said, "Never mind, I'm being taken care of." Lu thought that was kind of odd but didn't question it further. Duke thought it was good that they didn't have to be concerned about taking care of someone they had just met—only get and use his insider tips on exactly how to place the crooked bets.

On their journey to Florida, Lu and Duke had brought a satchel of $3,000 cash in tens and twenties from the kingpin, plus an extra $500 to cover their expenses. Lu also had $700 of his own to place private bets in addition to the ones he'd be placing for the kingpin. Duke had about $50 on him.

Both were armed, Lu with a .38-caliber pistol and Duke with an army .45. Lu had a handful of extra bullets for his already fully loaded .38. Duke had an extra clip of bullets for his gun. They also had an old Tommy gun that needed repairs. Lu loved that gun. He had seen gangsters using similar weapons in movies on the big screen. Big shots had Tommy guns. That was what Lu thought, even though the one they had was in need of repair and ammunition. But the gun looked impressive. Lu had bought it off some street thugs who had robbed the area police station earlier in Youngstown to get a stash of weapons. Lu chuckled about that, the police station itself being burglarized. That's where the real guns were, the ones confiscated in raids

and taken away from criminals. Lu related that many small towns throughout the Midwest only had a few officers at the police stations themselves. Easy pickings! I asked him if he had ever robbed a police station, he said no, but he knew plenty of his buddies who had.

Lu and Duke had plenty of cash to place their fixed bets, but one just doesn't leave stacks of money lying around in a hotel room. It'd be too easy for it to get stolen by the maid or other room tenants. Lu and Duke couldn't take and carry that much cash on their physical persons. They couldn't take it to a bank or leave it with hotel folks. Leaving it hidden in the room was out. They didn't want to rouse any suspicions that they were loaded with cash—$3,000 was an exorbitant amount of money in 1949. Lu's plan was to keep the money close by but safe.

There was a pine tree forest near the hotel that Lu and Duke could easily see from their second-floor hotel room window. When it got dark, Lu and Duke dug a two- by two-foot hole under the pine trees using their hands and small sticks. It was only about one foot deep. This is where they'd keep the money, a couple satchels full of cash. They would cover up the satchels with pine needles to make it look as natural and camouflaged as they could. It'd be easy for them to make quick trips to the hole to replenish and swap out cash as needed. Probably not the best and safest method, but it was their simple plan under the cover of darkness each night or early morning during their stay. It seemed okay.

During their first night's stay, they were partying and drinking with the jockey in the hotel room. The jockey also had the next day's racing sheet listing races and odds. He explained there would be "scratches." That meant horses would be withdrawing at the last minute. The jockey instructed Lu and Duke that the track announcer would keep them informed, as there would be late entries and time to change and place additional bets. He was full of insider tips, and Lu and Duke quickly became impressed with this guy. He instructed them to place bets on about twelve races a day; that would be plenty, and there would be no need to try to bet on every race, as there were so many of them—some to not even fool with.

The jockey asked, "Have you guys got plenty of cash? You'll need a lot. I want to work you up to the VIP counter and room with $100 minimum bets."

Duke blurted out, "We've got three big ones."

"$300 bucks ain't near enough," said the jockey.

"I'm talking about $3,000, not $300," said Duke.

"You got it here in the room with you?" asked the jockey.

"Of course not, but it's real close by," said Duke, as Lu's glaring eyes were telling him to shut up. They all took another belt of whiskey, and Lu noticed one particular race on the sheet that was even-money on the projected winner. That particular horse was probably supposed to win. The jockey immediately pointed out, "Do not place a bet on that one. He will not win. He's with us. He will not place in the top 3." They would go up and down the racing sheet, with Lu jotting down numerous notes on his pad. He was quickly learning the crooked business of fixed horse betting. The jockey made it clear that Duke and Lu were to make absolutely no contact with him while on the racetrack premises, not even a nod or wave and most certainly no conversation. They were to act as complete strangers.

The crooked jockey gave Lu and Duke three or four outright winners for the following day, plus seven to eight sure bets to place or show. Unforeseen things usually happened during races, meaning all four of those wouldn't necessary win, but they could and most always would "show" (meaning to place first, second or third; placing show bets was more of a method of producing a steady stream of low-profile money to be won).

Lu and Duke took more than $500 of the kingpin's money the first day to get a feel of things at the racetrack. They placed a few $1, $5 and $10 bets. By late afternoon, they were placing $20 bets. They did okay that first day. They started with $500 and came back with $800, not a bad haul for one day's work in 1949. Their jubilation began on the walk back over to their hotel room.

"Lu, this is a goldmine," Duke said. "Let's start tomorrow with $20 bets."

"Sure, I'm with you, but the kingpin told me not to get greedy. Let's get us some steaks for supper. There's time before we meet up with the jock. He's coming by the room at 11 tonight with tomorrow's betting stuff." There was a restaurant within walking distance of the hotel and track.

Lu and Duke enjoyed their steaks and four whiskey drinks each. They got back to their hotel room by 10:30 p.m. The jockey was already there, arriving a little bit earlier than the expected eleven o'clock. He had been waiting in the stairway, dragging on a cigarette. Lu nodded and motioned for him to join them in their hotel room. There was half of a large bottle of whiskey waiting there. This was their second night of meeting together. After a good belt each, passing the bottle around, Lu asked, "What does it look like for tomorrow? What goes good?"

The jockey said, "Here's the list, all written down." It had thirteen safe bets.

"Good," said Lu.

The jockey immediately left the room, saying, "See you tomorrow night, same time." Duke soon went to bed after a stagger down the hall to use the toilet. Lu told Duke that he'd be right back before turning in. He made a quick trip to the pine trees to get some cash for tomorrow's bets. In the moonlight, Lu could see their hidden spot covered over gently with pine needles. He pulled out the top satchel, opened it and grabbed a handful of cash, not knowing how much. He'd count it when he got back to the room. The short walk back in the moonlight only took a few minutes. Duke was asleep and snoring noticeably, so Lu decided to joke with him. He yelled, "Duke, wake up!"

"Huh?" a dazed Duke replied.

"Yea, wake up and go to sleep!" (Lu had remembered that line from a Three Stooges short film he had seen). Duke didn't acknowledge him and turned over to continue his sleep. Lu bedded down for the night thinking that he'd count the money he had just gotten from the buried satchel in the morning.

Duke woke up before Lu. It was shortly after 7:00 a.m. Lu was up soon afterward, as he heard Duke stirring around. There was a line down the hall waiting for the bathtubs. Lu and Duke decided to get baths later, after their usual breakfast of black coffee and cigarettes. Lu counted the money that he had dug up the night before. It was about $400 bucks. He put it in his pocket. That'd be plenty for today's venture of betting, plus he thought he'd win some of the house's money to bet with, too.

Lu and Duke walked to the nearby restaurant. After sipping several cups of Joe, they went back to the hotel and took baths, with ample time to get over to the track. Lu had their cheat sheet of information the jockey had supplied the night before. They'd grab a sandwich at the track, just as they had done the previous day.

The second day at the track was going well, almost too perfectly, as they cleared $500 in the first race placing three different bets in the same race. Lu and Duke now had $900 on their persons, and it was still midmorning. For the next race, Lu only bet $20. Duke thought he was crazy for not betting more and disagreed with him.

Lu said, "Here, take another twenty dollars and bet it any way you see fit." Duke took it and betted it quickly and wildly. Both Lu and Duke lost the money they each had bet. Lu had had a feeling and remembered what the kingpin had told him—to not get greedy or get caught up in the jazz of the moment.

During a few more races before lunch, Lu, with Duke always at his side, cleared fifty dollars. Duke was fidgety the whole time, wanting to place larger

and larger bets, but he always went along with Lu. Lu was the leader. Lu was the boss, and what he said went. Duke was okay with that as he, too, was a pretty smart fellow in his own right.

After lunch, Lu went overboard and bet the most amount he ever had on what looked like a sure thing. Even though it was "fixed" for Lu to win, live animals didn't know that. Horse, at times, act peculiarly and have their own minds. Lu lost a walloping $400 and then pulled out a whiskey bottle from his pocket and took a few long drinks. He offered the bottle to Duke.

Courtesy of the author.

He, too, took a few long drinks. It was midafternoon by now—still time to place bets on more races that were coming up. They had about the same amount of money they had started the day out with but were eager to place more bets.

"It must equal out, I guess. We're due to hit on the next race," Lu told Duke as he started looking at the cheat sheet. It panned out, and they cleared a few hundred dollars and called it a day. Now it was time to do some more drinking and maybe some womanizing. There was a dance hall across the road from the racetrack. "Time to unwind a little," Lu told Duke.

They stayed in the dancehall several hours, boozing it up, buying drinks for a few ladies who were working girls in the establishment. The time was getting away from them. It was getting close to 11:00 p.m., the time they were supposed to meet up with the jockey at the hotel for the next day's cheat sheet. They invited the girls over but told them to wait an hour, as they had some late-night business to conduct first. The girls agreed. Lu and Duke left in a brisk walk, though staggering somewhat from all the whiskey they had consumed. They got back to the hotel at 11:15 p.m. They couldn't find the jockey. They were late and must have just missed him.

"Duke, go back outside and look around. Maybe he's still nearby," Lu asked of Duke. Duke left the hotel room per Lu's instructions. Lu wanted to count today's money. He knew that he had left that morning with $400. And with all the bets, all the drinking, he wanted to know how much total money he had. He emptied his pockets onto the bed and started counting. $560 was the amount. Lu thought to himself, *It's okay. We started with $400*

this morning. I'll put the $560 in the satchel under the trees for the night and go back to it before daylight. We'll do some more serious betting tomorrow. I sure hope Duke finds the jockey. We need his cheat sheet.

Lu went down the second-floor steps. He never ran into Duke or the jockey on the way to the satchel's stash. Something was wrong, though. Lu could sense it. He took the journey to their secret hiding spot under the trees.

The hole was uncovered! The pine needles were scattered. Lu could see that in the pale moonlight as he frantically approached the spot. The two satchels were gone! All the money was gone! Lu looked around but didn't see a thing or anyone else. He quickly made it back to the hotel room to get his pistol left in a drawer near the window. Glancing out, he saw a dark figure loping around in the parking lot. Lu rushed downstairs and outside. It was Duke. He had been walking around in the night air trying to sober up a little. Duke did not know about anything that had just happened.

"That son of a bitch!" Lu mumbled to Duke.

"Who?"

"The jockey. He stole the money!"

"What? Are you sure?"

"Yes, I'm sure, but there's nothing we can do about it tonight. You didn't see him, did you?"

"No, and I was walking around, and nearby, too."

Lu replied, "Let's get some sleep and be at the track first thing in the morning. We'll ask around and find him."

"But didn't he tell us not to try to contact him at the track?" asked Duke.

"I don't give a rat's ass. We got to find that damn midget jockey!" exclaimed Lu. "He's ripped us off!"

The jockey was nowhere to be found when Lu and Duke snooped around the track the next day. The jockey had skipped out, more than likely out of town.

Lu decided, too, that it was time for him and Duke to leave town. They went back to their hotel, and to their surprise, there were two of their Youngstown friends there who had helped them years earlier during grocery store robberies. It was two women, both with the name Jeanne. They were older than Lu and Duke and very attractive at twenty-four and twenty-seven. They were party girls. Lu asked them what they were doing there and how they had found them. The girls said that there was too much heat back home and they needed to get away for a while, so here they were. They just asked around and told others that they were their wives. Lu was not too glad to see them but told them that he and Duke had to get back home and were

heading out that day. A cool Lu informed the girls that he'd take care of the room for a few more days and gave them fifty dollars.

The girls wanted to hit a grocery store or two, like old times. Lu told them not this time and not in this area. They didn't know it well enough. That would be the last time that he and Duke ever saw those girls. (He came to find out later that the girls robbed a Florida store or two on their own.)

The Miami trip was not successful. Lu was extremely distraught about the jockey giving them the shaft. He was ready to leave and get the hell out of town. Lu and Duke had gone there to bet on fixed horse races but ended up getting robbed themselves. Even in the later stages of his life, Lu told me he was still looking for that jockey. He never found him.

Lu and Duke were now ready to work their way back home, taking the long route via train up the eastern seaboard to Washington, D.C., which was a main hub and connecting point for their travel to get back home to Youngstown. There was no hurry, but Lu had to tell the kingpin what had happened. He did so over the phone before they left Coral Gables.

The kingpin fully believed Lu and said that he'd deal with the jockey. He asked Lu if they had money to get home. Lu told him yes and noted that they'd try some skirt-chasing up the eastern seaboard during their train ride to ease their frustrations. Lu also informed him that he'd check in every few days for any word on the jockey and asked if he could help get him once found.

Thus, the jockey had the money and had skipped out. Lu and Duke had been instructed to place bets with the jockey's insider tips when they first arrived in Coral Gables. They did per the kingpin's instructions. Everything was going fine until the jockey double-crossed them. It was time for Lu and Duke to recuperate from the Florida experience and sober up for a day or two. They took a taxi to the train terminal in Miami to board for Washington, D.C. There they'd transfer to another train to get back home to Ohio.

The hell with Miami and Coral Gables!

CHAPTER 3

All Aboard!

The look on his face when he saw a suitcase of cash and guns…
—Lu, referring to the porter

The train trip from Miami to D.C. was uneventful, with routine stops at stations to stretch one's legs and bathroom breaks. Passengers who didn't want to eat on the train grabbed cold sandwiches at the various train terminals during the route. Lu and Duke dozed most of the time, as they were exhausted from the past few days in Miami. They still were upset about the jockey ripping them off, but they thought that one day he'd surely get his due. Along with the kingpin, they would be looking for him. Lu and Duke didn't want to kill him, just confront him. The kingpin would probably do much worse.

Duke, at first, didn't think the kingpin would believe their story of them being robbed. They had lost $3,000 of his money. Lu comforted Duke in that the kingpin fully believed him, as Lu had telephoned to inform him earlier. "He knows me, he believes me. Somehow, someday, I'll make it up to him," said a concerned Lu. (Lu did pay back every penny, with fair interest, years later from being in the nightclub business.)

"Me, too, I'll help you, Lu. You know that," Duke consoled Lu.

"That damn midget's days are numbered," Lu reassured Duke.

Lu and Duke traveled light for their train trip. The first leg of their journey back home to Youngstown, Ohio, was from Miami to Washington, D.C. That was the Baltimore & Ohio (B&O) part of their route. One of their

suitcases had some clothes and shoes. The other had their stash of cash, underwear and guns—Lu's .38, Duke's .45 and the broken Tommy gun. They didn't have much pocket cash on them. Lu and Duke were like regular train passengers among other travelers.

At the D.C. terminal, they boarded a sleek, brand-new diesel streamliner that was a first of its kind. Named the Ambassador, it was the pride of the B&O railroad line in 1949. It was one of America's first diesel passenger trains. Its express routes covered the distances between the Baltimore area and St. Louis, with a major boarding hub in Washington, D.C. It also stopped at various cities in between.

The railroad line marketed itself as offering a very secure and safe traveling mode of transportation, with its passengers' safety always the number one goal and priority. Lu said that was pretty much "bull" that made good press, especially the parts about them promoting that they had undercover private detectives on board. The Ambassador train that Lu and Duke traveled on had no security of any type.

Lu and Duke's bags were loaded into a baggage car along with those of the other passengers. The contents of the bags weren't closely inspected, for in 1949, there were no real safety-in-mind measures in place for boarding a train as passengers.

This state-of-the-art Ambassador train could hold about 150 passengers. Its leg of the journey from D.C. to Detroit was filled to capacity with well-to-

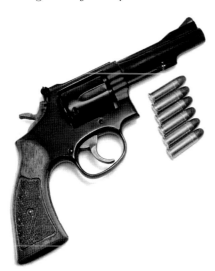

do wealthy travelers such as diplomats, politicians, corporate executives, their wives and families. Lu and Duke would fit right in, as for fun and fashion they had bought some fancy clothes at a nearby men's store near the D.C. terminal while waiting for their train. They had purchased some zoot suits complete with stylish hats. Lu's suit was light blue and Duke's a light gray.

A zoot suit consisted of a long coat with wide lapels and padded shoulders with high-waisted wider-legged pegged trousers. The wardrobe was commonly accompanied with a pocket watch with a long, flashy chain and

A gun similar to Lu's .38. *Courtesy of the author.*

41

a color-coordinated hat. Lu and Duke had everything except the pocket watches, but they were still most certainly styling, with the dignities of big shots. Later, the press would call them the "Zoot Suit Bandits," although Lu said that the real zoot suit craze had come about a decade earlier.

As the B&O Ambassador pulled out of the Washington, D.C. terminal, Lu and Duke found their seats and plopped down. They were sitting next to each other. All the seats were nice and roomy. They were on a high-class train. Lu told Duke to relax a few minutes before they'd head over to the dining and club car to get a drink and some grub. Duke was more of the worrier between the two. He was immensely concerned about the crime boss's money being ripped off.

Lu consoled him. "Sack out for a little while. I'll wake you when it's time to eat. Rest up a while. We'll be OK." Within a few minutes, Duke was lulled to sleep by the soothing, monotonous, repetitive sounds of the train's wheels gliding over the rails. Lu remained awake and glanced around the luxurious coach. It was very fancy compared to other trains he had ridden on before. He glanced out the window at the passing landscape, and he, too,

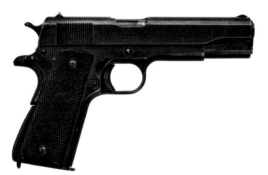

Left: A gun similar to Duke's .45. *Courtesy of the author.*

Below: A gun similar to the bandits' nonworking Tommy gun. *Courtesy of the author.*

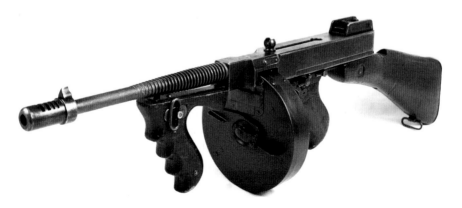

couldn't help but think about the Miami experience. Things had been going well until that jockey screwed them over. Lu hoped that he'd find him one day and settle the score. He was in deep thought and didn't realize that the conductor had walked up to his and Duke's passenger aisle.

"Tickets, please. May I see your tickets please?"

"Yea, just a minute," said Lu as he reached into Duke's front jacket pocket to get his. Lu handed both tickets over to the conductor, who punched them and handed them back. The conductor thanked them and politely informed, "Next stop Martinsburg, West Virginia. Arrival in a few minutes."

"Can I get a pillow?" Lu asked the conductor.

"Sure thing," the conductor obliged, bringing over a little blanket, too. "It gets cold traveling in the West Virginia mountains this time of year." Lu shook his head and took both the blanket and pillow. As the conductor was walking away to the next aisle to punch tickets, Lu blurted out, "Some grub and a drink, when can we get some?"

The conductor turned back around and pointed to the rear of the train. "The club car is a couple cars back. They serve dinner from 6 to 9."

"What about getting a drink?"

"You can get a drink back there most anytime."

"Thanks," Lu said as he poked Duke on the leg to wake up.

Duke was startled, his eyes popping wide as he jumped up. "What's wrong?"

Lu chuckled and said, "Nothing. You ready to get a drink and something to eat? You can sleep at home." Duke had been dozing no more than ten minutes.

"Yep, sounds like good advice, but more than a drink. I'm in, let's go."

"How again do we get to the club car?" Lu asked the conductor who was still nearby.

"Just go to the door at the back of this car we're on, go through one more car, and it's the next one. You can't miss it."

Lu and Duke rose up and started making their way back to the club car using their hands and arms to steady themselves on the aisle seats as the train progressively sped along. They noticed all the high-class passengers, mainly the ladies with elegant furs who were also wearing fancy jewelry. Eye contact was made with many of the passengers, as Lu and Duke aroused stares and attention on account of their flamboyant zoot suits. Attention was certainly attracted whether they meant to or not. Most everyone noticed them in the car they were in and in the adjourning car as they made their way to the club car.

Upon getting to the club car, Lu and Duke discovered a massive party going on. It seemed that there were others buying drinks for everyone. Lu and Duke wanted to fit right in. Lu checked the prices out of curiosity, since they were a captive audience on a moving train. The alcoholic beverages ran between $0.85 and $1.75, depending on the drink, with brandy being the most expensive. There were some specials at $0.50. Lu thought the overall pricing was okay, though somewhat steep, but they were on a high-class Ambassador train, after all.

There were about fifteen people in the club car boozing it up, more women than men. Lu and Duke loved that. A stranger blurted out, "Drinks on me. Get what you want. This round's on me." Lu and Duke ordered whiskey shots. Another man near the bar counter said, "I'll have the same. In fact, as soon as you pour that one, pour us all another. It's on me."

That gentleman who did the extra ordering downed those two shots pretty quick, as did Lu and Duke. As soon as that happened, the first man who had shouted, "Drinks on me," shouted it again. "The whole car, drinks on me!" After three shots on an empty stomach, Lu and Duke were feeling the effects of the alcohol. It was getting early evening and nearing darkness. It seemed that many around them were experiencing the same. It was time for Lu and Duke to buy or order a round or two for the whole car. They did this a time or two before losing count. The booze was flowing freely. Their bar tab was getting larger and larger. They had money, but not much on their persons. Most of their cash was in one of their suitcases in the baggage car.

After a few minutes of hard drinking, Lu and Duke were asked to take care of their tab. Lu said, "But we ain't finished drinking yet!"

Duke said, "Neither am I." The bartender was nice but professional in asking again. He was experienced in dealing with drunks, especially captive ones in his bar on the train.

Lu retorted, "We got money, just not on us. It's in our bags on this train."

"Can you please, then, go and get it?" he replied as he met Lu's piercing stare. "I'll get someone to go with you and to help you," replied the sympathetic bartender, who wanted all his tabs fully accounted for.

Lu's temper building, he replied, "That's fine, you non-trusting bastard, and here, hold my hat as collateral. Duke, lend him yours, too. Here, take both our hats as temporary collateral since you don't believe us."

"That won't be necessary, sir, but I'll honor your wishes," said the apologetic bartender.

They gave up their flamboyant zoot suit hats to the reluctant bartender. He carefully placed their hats behind the bar counter and said, "Sure,

sir, I'll keep them safely for you until you want them back, no problem, glad to assist. I'll watch after them and give them to you when you get back. Also, your next round is on me." The bartender motioned to a porter to lend assistance. Lu was still very upset that he wasn't trusted. It really made him mad. He had money, just not on his physical person in the club car. It was stashed away in one of his bags in the baggage car. Lu was trying to understand the reasoning of the bartender. The several whiskey shots on an empty stomach added to his confusion and aided in his belligerence.

The baggage car was located the next car back from the club car, really not that much of an inconvenience. The snag would be finding the right bag out of all the ones stacked on top or behind one another. With a good amount of already consumed alcohol altering his judgment somewhat, Lu was fuming almost to a fever pitch. He thought to himself, *Where am I going to go? I'm on a moving train after all.*

The club car was still hopping and lively. Intoxicated partying people were everywhere. As Lu and Duke made their way to the rear of the car to get to the back door that led to the next car, their new drinking friends were asking, "Hey, where you guys going? Don't leave yet, have another drink."

Lu said, "Yea, thanks, we'll be right back."

The porter, a black man in his fifties, unlocked the rear door of the club car and the passageway to the baggage car. It wasn't a secure lock, just a safety bar that could be easily raised to open the door. Lu and Duke were right with him. The area between the two cars was extremely noisy with the normal sounds from the fast-moving train. It was difficult to keep one's balance, especially after several drinks. It was only somewhat safe to be going from one car to another, but onward they trekked.

Lu, Duke and the porter got into the baggage car. It was packed with suitcases and bags all the way to the ceiling, with a small alleyway to journey to the back of the car if needed. There wasn't much light. The porter got right into Lu's face to speak loudly over the train noise: "You got your baggage claim ticket?"

Lu asked, "What? I didn't understand you." Lu thought the porter was being a smart-aleck, but he really wasn't.

The porter yelled even louder than the first time: "Baggage ticket. Claim number to find your bags!"

Lu shouted, "OK!" as he dug into his pants pocket. He pulled it out fairly quickly and handed it to the porter; Lu was still upset at having to come back here in the first place.

Courtesy of the author.

The porter, who knew the baggage car very well, looked at the ticket and said, "We're lucky. Yours are right on top. Let me pull them down. I think I can make out the two of them that are yours."

"Yea, you get 'em so you can get your damn money," remarked Lu. "But you're good; there must be a couple hundred bags in here."

The porter jumped up, trying to grab one of Lu and Duke's bags. He snatched at the handle and moved the suitcase a little. On the second jump, he jerked it down trying to break its fall. It came crashing down as Lu, Duke and the porter quickly moved out of its way. The suitcase made it to the floor but got lodged in the baggage car's alleyway between other stacks of suitcases and bags.

"Hell, it's the other one, not this one," Lu said, pointing up toward his other bag. "Let me get it. I can reach it. Get out of the way, it's my bag."

"Regulations, I have to get it," corrected the porter.

"Go ahead, get the damn bag. Step back out of his way, Duke. Let him have a go at it, but I'm getting tired of all this crap."

While the porter was getting ready to reach up for the second bag, Lu pulled his and Duke's first bag free that had gotten wedged close to the floor. But what was still needed was their second bag. It was still up high and stacked up on the pile of numerous suitcases in the baggage car. Duke

moved back a little in the dimly lit car. His patience was wearing thin, as well. Everything was so cramped—three humans right on top of one another, with no extra room.

The porter jumped and pulled at the other bag. It seemed stuck, jammed up near the ceiling. He jumped again and again gently moved it a little. Finally, he pried it out with a stout tug of his arm. At last it came crashing down. The porter couldn't slow its fall. Everyone got out of the way. It crashed down on the floor and burst open on impact, startling everyone.

Cash went flying! The Tommy gun flew out and clanked against the baggage car floor. The porter's eyes lit up. He was mesmerized. He was frozen in disbelief, fear and amazement. He didn't know what to do or think. Things had happened so fast. He had pulled down a suitcase with guns and cash, and he was in proximity of the owners.

Lu saw his .38 pistol still in the suitcase but on top of one of the flung-open sides. He immediately scooped it up, put it in his gun hand, pulled back the gun's hammer and pointed it in the porter's face. Lu grabbed the front of the porter's shirt and said, "Now give me all your money. Duke, get your gun and pick up all our cash."

Duke said, "Yea, doing it now." The porter was speechless as Lu was manhandling him; by now, Lu had pushed him up against a stack of suitcases. Lu pulled the gun out of his face. The porter was not moving, as he feared for his life. Lu instructed Duke, "Cock your piece." Duke did just that and was following Lu's on-the-spot instructions. Lu had his .38 and Duke his .45.

"And now back to you," Lu yelled to the porter. "Give us your money, and your damn cap, too," Lu said as he snatched it off his head. "You got our hats, and now I got yours."

"What sir? I don't have any money. I never carry any on me while working," protested the porter.

Lu came right back with, "I want you to stop this damn train, too."

"What?" questioned the porter.

"Stop this damn train. We're ready to get off," Lu demanded again.

"I can't do this. We're going down a mountain. Grade's too steep. That's crazy," pleaded the porter.

"Pull the damn emergency cord," Lu said, waving the gun in the porter's face.

"Yes, sir," the porter replied, reaching up with his right hand to the cord. Lu and Duke donned no masks or disguises.

The bedlam was starting!

CHAPTER 4

The Takeover

I never wanted to kill anybody.
—Luman Ramsdell

The Ambassador passenger train was making its way westward. It was just a few minutes out of the D.C. terminal and had reached the edge of the West Virginia mountains. Everything was proceeding on normal schedule. The grade was becoming more erratic along the route, which was sprinkled with hills and valleys. The mighty vessel would gain speed going down the various inclines. Doing that would help it generate momentum to climb the next.

The streamliner's 147 passengers and crew were enjoying the luxurious travel on the state-of-the-art train. It was the pride of the Baltimore & Ohio railway line. A perfect trip—almost too perfect. An unfolding tragedy loomed. Soon the Ambassador would be coming to a screeching halt in the desolate mountains of West Virginia. The unsuspecting passengers and the train's personnel didn't realize that the baggage car was being taken over by Lu and his "gang."

Newspaper articles would have it wrong in saying that there were at least four bandits, as it really was only Lu and Duke who started all the bedlam, mayhem and terror.

Meanwhile, back in the baggage car, Lu instructed the porter to stop the train. The porter initially resisted. "You're crazy. We can't stop this train," the porter protested.

Courtesy of the author.

"Do it. Do it now," Lu said as he waved his cocked .38 pistol in the direction of the porter's face.

"No, I can't. I won't do it. It's too dangerous," the gravely concerned porter said.

"I'll show you dangerous."

Lu pressed the barrel of his pistol into the porter's nose and then quickly pulled it away, firing a shot into the baggage car's floor. He knew that no one else on the train would hear the shot. They were isolated in the baggage car—just Lu, Duke and the porter. Lu cocked his pistol and again shoved it into the porter's face, saying, "Last chance. Do it or else."

The porter could smell the gun smoke from Lu's pistol and was immensely frightened. He had no choice. He didn't want to die in the baggage car on this god-forsaken mountain. This time, the porter reached up and yanked the emergency cord. It was a coded tug—two quick ones, a delay and then a longer, more sustained one. The engineer in the head engine car knew that it was serious and that it had been generated from one of the train's personnel. He knew that he had to stop the train right away.

Lu, Duke and the porter all swayed as the train began slowing. Lu put his gun-free hand out to brace himself against the stacks of bags and satchels. Duke soon followed to keep himself from stumbling and falling over. The porter also steadied himself.

The outside noise of metal grinding against metal was only overshadowed by the hissing of steam and the train's brakes starting to grab hold. The loud rumblings up and down the train's cars pierced the West Virginia early evening air. It was very dark and cold outside. It took several minutes for the entire train to come to a complete stop. It finally did, and passengers, panicked from the unannounced stop, didn't know what to think. Their fears of uncertainty were quickly materializing. The train was only five to six miles outside Martinsburg, West Virginia.

Lu sarcastically thanked the porter with a nod for pulling the emergency cord to get the train stopped. "Good job. Now do exactly as I say and you won't get hurt. Do you understand?"

"Yes."

"Say it again, but louder."

"Yes, sir!"

"Duke, keep your piece on him. Let me take a quick look outside." The porter raised both his hands and arms. As Lu looked outside, he could see nothing but pitch blackness. The two bandits had successfully stopped the train. Lu leaned out and stepped onto the connect platform between cars. He gazed up and down the rails along the mountainside and quickly surmised that they were in the middle of nowhere. Duke and the porter stayed in the baggage car, with Duke's army .45 trained on him to thwart any sudden moves.

After being outside, Lu worked his way back inside the baggage car, holding on to a banister between the cars, and told Duke, "Time to rob her now."

"Yea, I agree," said Duke, as he was more than ready to help and follow Lu. "But how are we going to do it?"

"We'll mug and rob a few passengers first. Let's go back into the passenger car. You stay in there near them. I'm going to work my way up to the engine car. Keep your .45 out and be waving it around. Point it at as many people as you can but don't shoot anybody. We just want their valuables and to get the hell out of here and off this train."

"Yea, OK, loot 'em and scare 'em," an eager Duke agreed. "I don't think they'll pose too much trouble, do you?"

"There's always one who thinks he's a hero," Lu warned Duke. "Be on the lookout for him. Make sure your gun is out and showing at all times. Don't hesitate to fire off a shot or two to keep everybody's attention."

"Should I make them get to the floor?"

"Yea, and slug one or two of them with your gun handle and knock them down to the floor in front of their seats. Show them we mean business. The rest will do what you say on seeing that, OK?"

With bullets and gun butts, bandits broke the glass in this dining car door to open the door and enter to rob the passengers. Steward George R. Groves argued with the bandits but escaped uninjured.—News Photos.

Oscar the Monster Is Too Shy to Float

CHURUBUSCO, Ind., March 0.—(P)—Farmer Gale Harris sought the aid of an expert diver today to help him capture Oscar, the monster turtle at Fulks Lake.

thought the diver could find the monster, pump it full of air, and float it to the surface. Many people hereabouts, including Harris and members of his family, say they have seen the giant reptile. They

snapper weighing 400 to 500 pounds and has a head the size of a year-old baby's. Dozens of people have flocked to the lake on Harris' farm for a try at capturing Oscar.

de of this dining car with the smashed pane, Mr. and Mrs. Hy Dahlka and their daughter Sandra, 4, lay on the floor in a litter of broken dishes while the bandits battered an ence. The Dahlkas were en route from Washington to their home in Gibr

Courtesy of News Photos.

"OK, but I don't want to shoot anybody either," said a willing Duke.

"You'll do what you have to do. So will I."

Duke asked Lu, "Why do you want to get to the engine car? Why don't we get what loot we can and jump off?"

"Have you looked outside? It's pitch black, and we're on the side of a mountain in the middle of nowhere."

"But what if another train comes barreling down on us? If so, we're all goners," said a concerned Duke.

"Just hope not. No use praying about it. We'll be OK. I know we will," said a reassuring Lu. "I remember a lighted area along the tracks a few miles back. I'm gonna make the engineer back this sucker up. We'll get off there and take our chances. Let's go, Duke, and come on, Mr. Porter. I'm in charge now, not you," Lu said as he pointed to the cap he was now sarcastically and proudly wearing as he waved his .38 at the porter.

The three souls were in the baggage car. The sequence of the train's cars going from the baggage car to the engine at the train's front was the baggage car, a coach or passenger car, followed by the dining and club car, another passenger car and then two engine cars. There were additional passenger cars and another baggage car farther back on the train, but Lu and Duke were only concerned with the front half, as they wanted to work their way forward for Lu to get to the engine car.

"All right, Mr. Porter, lead us," Lu said as he grabbed him by the back of the shirt collar while giving him a push out of the baggage car. The porter was also wearing his official-looking white formal jacket, part of the train personnel's garb. "No funny business. You yell out to the passengers that they're being robbed when we go in. Remember, exactly as I say and you won't get hurt."

They exited the baggage car, making the few steps over the connection to the passenger car. Both Lu and Duke's weapons were drawn, cocked and ready to fire. By this time, the train had completely stopped.

"Yes sir, exactly as you say," said the terrified, hatless porter. This porter was not the hero type. His hand and arms were not bound or tied, as Lu had his gun-free hand locked in the back of the porter's white jacket collar. Lu's other hand had the cocked .38, and Duke was right behind ready to assist as needed.

When they burst through the door at the rear of the passenger car, they created quite a stir. The travelers near the back of the car saw the porter first and Lu's shiny .38 pistol. They were shocked and immediately frozen in disbelief and fear. They could see the commotion and confusion.

"Do what they want, and you won't get hurt," yelled the porter. There was a deafening silence that started from the rear of the car and moved in a wave all the way to the front. There was already chaos brewing from the train being stopped, as passenger after passenger soon realized that there was much more imminent danger.

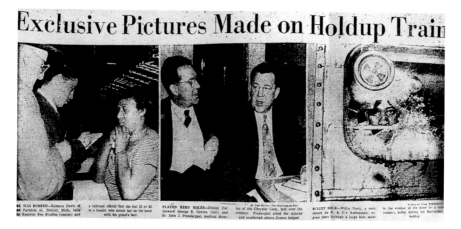

Courtesy of the Washington Post.

The train was still, but the pandemonium had started. Some of the frightened passengers were ducking down, and others had become paralyzed in fear. Others still were frantically trying to hide their valuables. A handful at the front of the passenger car quickly opened the front door leading to the next car. They escaped for the time being to the next car, which was the dining or club car. Lu and Duke couldn't stop them, as they still had the porter in a stronghold at the rear of the car. Lu thought about shooting toward the front, but he did not.

A male passenger close to Lu was looking at him. Lu leaned over and swatted his head with the butt of his pistol. The guy fell bleeding and bruised to the floor. Lu reached over the aisle and swatted another gentleman the same way. "Please do as they say," yelled the porter. "Put your heads down. Stay in your seat. Be quiet. Stay seated."

"Yea, do that. Don't look up. Don't look at us," Lu said as he bellowed out instructions for the horror-struck passengers. By now, Duke was in front of Lu, as Lu let go of the porter's collar.

"You stand still, and right there," Lu said as he instructed the porter to stand near the rear of the car. "No funny business, or you'll be shot first!" There was a soldier dressed in his traveling uniform seated in the third aisle from the back who made eye contact with Lu. The head bandit approached him, pushed the gun against his chest and flicked an award ribbon that the soldier was wearing.

From a passenger's later account, it was noted, "I thought he was going to shoot him and so did the soldier. If there had been one hero aboard that train—we would all be dead. Those men looked as if they would shoot any one who tried to stop them. They seemed to be doped or something."

Lu and Duke were doped, but on whiskey. Lu had no intention of shooting anyone, especially a fellow soldier, as Lu himself was a marine who had served his country by fighting during World War II. Even as drunk as they both were, Lu and Duke did not want to shoot anybody. Lu lifted the seventy-six-dollar furlough pay that the private had on him but left him unharmed. Lu would not strike a fellow serviceman.

Once everyone realized that Lu and Duke meant business, Lu yelled out, "This is a stickup. Throw your wallets out on the floor in the aisle." Most everyone hysterically did, some faster than others. Lu told this writer, "Most of the men did. The old biddies [ladies] wouldn't, at least not all of them. It became kind of a joke between me and Duke. One old biddy wouldn't give up her necklace, so I slapped her across the face. And she still wouldn't give

Porter Willard Pendleton points to a bullet hole in the rug of the club car. One of the bandits shot the bullet into the floor.—News Photo.

Maxine Camp, 24, of Akron, O., and Donald Dreher, 22, of 320 Junction avenue north, discuss the robbery. Miss Camp and Dreher hid during the holdup and escaped being robbed.—AP Wirephoto.

Courtesy of AP Wirephoto.

up that damn necklace. Duke was grinning at me. I cussed her and left her alone. I moved to the next person in another row."

"Let me have your bills," Lu demanded of the next seated passenger.

A male passenger in his sixties said, "I ain't got none."

Lu gazed over at Duke, who had Lu's back covered, as Duke jokingly held up two fingers denoting, "Strike two" (for Lu's two consecutive failed attempts to get loot from passengers). It was now becoming a game, possibly a deadly one for the bandits and the innocents. Duke was ready to upstage Lu. Duke approached a black passenger in his thirties. "Now it's your turn to hand over your money," Duke said as he waved his .45.

The man handed him ninety-five cents. Duke threw it in his face and told him he wasn't taking that kind. He only wanted paper money. The passenger replied that he had only started out with one dollar and had bought a nickel cup of coffee—that was all he had left. Duke said that no one would board a train with only one dollar, so he smacked the gentleman on the cheek with the barrel of his gun, leaving a large bruise. Duke started moving toward the next row of frightened passengers. He and Lu were in single file in the middle aisle. Lu was back in front of Duke at this time.

Lu felt like he needed a human shield, so he jerked up a man in his forties and instructed him to walk in the aisle in front of him. This man was told

to pick up the tossed wallets and purses that were in the aisle. The man was also told to take the bills out and hand the cash back to Lu; he felt Lu's .38 pressing into the back of his neck.

Slowly and progressively, Lu and Duke worked their way to the front of the passenger car, looting as many as they could. Lu was still wearing the porter's hat, as the porter stood quietly near the back of the car, as Lu had instructed him. He was obeying orders not to move.

From a female passenger's account, "A bandit [Duke] knocked my glasses off when I said you're not getting my purse." In that particular instance, Duke snatched it from her as she was clutching it across her chest. He flung it hard against a train window. It did not open, and Duke moved forward, picking up various wallets and jewelry pieces that had been tossed into the aisle.

A male passenger was later quoted, "I was reading a magazine as we stopped at Martinsburg. After the train left the station and got a few miles west of town it stopped for some unexplained reason. The first time I knew that something

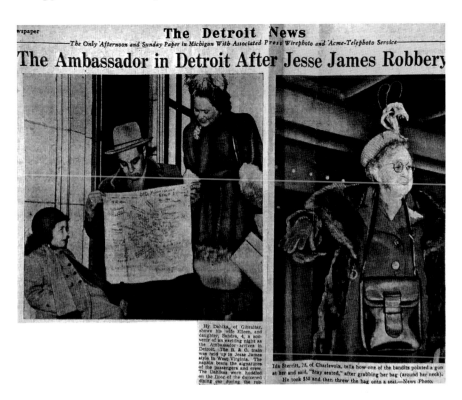

The Detroit News
—The Only Afternoon and Sunday Paper in Michigan With Associated Press Wirephoto and Acme-Telephoto Service—

The Ambassador in Detroit After Jesse James Robbery

My. Dahilka, of Gibraltar, shows his wife Eileen, and daughter, Sandra, 4, a souvenir of an exciting night as the Ambassador arrives in Detroit. The B. & O. train was held up in Jesse James style in West Virginia. The napkin bears the signatures of the passengers and crew. The Dahilkas were huddled on the floor of the darkened dining car during the rob.

Ida Sterritt, 28, of Charlevoix, tells how one of the bandits pointed a gun at her and said, "Stay seated," after grabbing her bag (around her neck). He took $50 and then threw the bag onto a seat.—News Photo.

Courtesy of the Detroit News.

was wrong was when a man came in and yelled, 'This is a stickup.' I sat still and when he came by me I grabbed his hands. He had a gun in his right hand. He got his left hand loose from me and hit me across the face, cutting my nose. I slumped down in a chair and acted like I was dazed. The bandit forced one of the other passengers to walk along, take money from each wallet and hand the money to the bandit. I didn't lose a dime.""

Although the train robbery and halting of the Ambassador terrorized so many people and occurred only a few miles from Martinsburg, less than a handful of Martinsburg citizens were actual eyewitnesses to the escapade or riding on that train. One, who was a garage employee, was robbed of sixty-four dollars. Another and his wife, who were store owners, escaped molestation in the dining car. They believed that there were several others mixed up in the affair and that two bandits could not have stopped the train and started their robbing campaign. They were sure that it had to have been several bandits and not a spur-of-the-moment caper, as later revealed. The couple also thought that the incident had to have been well planned and masterminded.

The ones at the front of the passenger coach who had safely escaped at the beginning of all the commotion were trying to warn others in the next car, the dining car.

"Let's barricade and lock this entrance so they can't get to us," a quick-thinking passenger shouted out from the confines of the dining car. "Let them stay trapped back there until help arrives." In the confusion, that passenger and the ones he was talking to never left their current car to provide possible assistance.

A dining car waiter disagreed and blurted out, "We've got to help the folks back there. They may be getting killed one by one for all we know. That gang of thugs may be killing them. We've got to do something. What? I don't know. God help us all." The door to the dining car had a glass window and push-down bar that stretched across it. The bar could be pushed into place across the window of the dining car's rear door.

There was still chaos in the passenger car. A kitchen chef on the train was trying to be a lookout from the safety of the glass window in the door of the dining car. It was very tight quarters. Suddenly, Lu appeared and could see the chef behind the glass. Lu had worked his way to that next car.

"Don't shoot," yelled the chef from behind the glass. Lu couldn't hear him but could easily read his lips.

"Like hell I won't!" Lu said as he raised his pistol and fired two shots into the glass only about two to three inches apart. The chef ducked down and

Estimated $1,400 Taken From Passengers On Train By Bandits

Interviews by United Press representatives with passengers and train officials at Cumberland, Md., the held-u Baltimore and Ohio train's first stop after the robbery, revealed that approximately $1,400 was taken by the two hold-up men just outside of Martinsburg last night shortly after 7:30.

Following is the story as reported by the United Press:

The robbery apparently was planned "on the spur of the moment" after one of the men was caught pilfering from a Pullman comportment.

Mrs. Rebecca Davis, 42, Detroit, who had been sittin" in the seat behind the men, said after the conductor led the pilferer back to his seat the two men sat "talking and acting kind of nervous."

Suddenly the men leaped to their feet, drawing .45 automatics.

"All of you put your heads down and put your damn pocketbooks and wallets over your heads," one of the unmasked bandits shouted.

Mrs. Davis said most of the passengers hesitated until the bandit waved his gun and growled:

"Make it damn snappy or you'll lose your heads."

When the robber found only $2 in Mrs. Davis' purse he angrily struck her behind the left ear with his gun butt, dazing her.

R. J. Morrison, superintendent of the Cumberland division of the railroad, estimated that $767 was taken from coach passengers, $200 from Pullman passengers, $167 from the train crew and $300 from the dining car cashbox. He said the bandits made no effort to bother mail shipments.

Walter Epps, Washington, dining car steward, was wounded when one of the bandits fired warning shots into the door of the club car. Epps was hit in the calf of the leg by a ricocheting bullet.

A Cumberland (Md.) shoe store operator, Morton W. Peskin, was the first passenger robbed.

"The robber held a gun against the back of my head," Peskin said, "and said, 'give me your money or I'll shoot.'"

Women passengers said one of the bandits had "beautiful black wavy hair" and that both "acted dopey" as though under the influence of narcotics.

Ann Linn, 17, of Cumberland, returning from a New York Herald-Tribune High School News Forum, witnessed the beginning of the robbery.

"We didn't know there was anything wrong at first because the men had their guns in their pockets," she said. "Then they pulled out their guns and made the conductor pull the emergency cord.

"The engineer came back to see what was wrong and they beat him up pretty badly and swore at him. They made us all sit down on the floor. One of them said, 'put your hands over your head and don't look up or we'll shoot you all.'

"So we sat down on the floor. I was trying to hide some money when they came to me. But they saw me and I had to give it to them. There were two soldiers in our car. They made one lie down on the floor. One of the holdup men stuck his gun in the older one's face and asked for his money.

"The soldier gave the man his money and he went away. They

Courtesy of the Martinsburg Journal.

was struck by some of the flying glass. He didn't have time to holler out a warning to others before Lu fired. The chef was trying to save his own life as things happened so frantically.

The head bandit next used the butt of his pistol to break out the larger chunks of glass to get his hand in around the cracks and holes that his bullets had created. He was now able to reach in to grasp and unlock the bar securing the door. Doing that, he made it into the dining car.

Lu was still wearing the porter's hat. Duke stayed back in the car behind Lu's present car. The head bandit was stampeding forward. One of Lu's

bullets that he had fired into the glass window of the door ricocheted and struck the chef in the right ankle causing a two-inch laceration. This turned out to be the only person shot or struck by bullets from either Lu or Duke's shots fired on the train. A waiter in the dining car fell from a stool during all the excitement and injured his leg. Neither the chef's nor the waiter's injury was life threatening. Another dining car waiter said later that the two bandits ate an elaborate meal before their robbing spree but couldn't pay their entire bill, promising to come back later and square up. "They sure did," he added.

Duke was still terrorizing the passengers in the passenger car. He had command of the car, as everyone was cowering in their seats or crunched down in the small floor space in front of their seats. The car was a mess, with purses and wallets strewn about the center aisle. There were furs, jewelry, necklaces, watches and rings scattered all around. The center aisle was cleared of people but was also cluttered with coats, hats and empty handbags that had been looted.

The two bandits simply didn't have enough pockets to carry all of the loot. They had gotten about all that each could carry, and their zoot suits' inner pockets were stuffed. The bandits continued to wave their weapons, Duke while in the passenger car and Lu as he was overtaking the dining car. Most all of the passengers still feared for their lives, cowering in their seats and slumping to the floor. Many were praying. Women were crying. Men were gasping. There were very few children on board. Lu did not remember any.

It was his train!

CHAPTER 5

To the Engine Car!

I hoped another train wouldn't come barreling down on us.
—Luman Ramsdell

A ticket agent at the B&O's Connellsville, Pennsylvania station later commented that the holdup and train stoppage were well planned: "There are trains which arrive in Martinsburg within minutes of each other, all going west. The Capitol gets in at 7:00 p.m., the Columbian at 7:10 p.m., and the Ambassador at 7:24 p.m. If either the Capitol or Columbian had been held up and stopped, the next train would have crashed into it. But after the Ambassador there was no other westbound train arriving until 10:19 p.m. The fellows who held up the train studied their schedules."

But that was untrue. Lu and Duke were concerned in the back of their minds about another train that might come barreling down on them, but they had no clue of any other train's schedule on the same track. They were just plain lucky with their timing that trains didn't collide.

A newspaper account of interviews with various people afterward related the takeover of the passenger car: "They [the bandits] asked one lady to open her purse, but they didn't take any of the money and were using terrible words when they saw how little cash was in the purse." Another lady yelled, "Why doesn't someone stop these people?" and was hit over the head with the butt of the gun by one of the holdup men. One lady, aged fifty, lost just $4, as that was all that she had with her. A navy physicist was robbed of $50 dollars and suffered a panic attack. One of the train's conductors was hit on

the left side of his head with a gun by one of the robbers. Another lady was hit behind the left ear when she attempted to argue with the robbers. She was repulsed by the foul words used by the two men. One young lady the same age as Lu, twenty-three, said that one of the robbers took $50 from her. While one robbed the passengers, she said, the other kept them covered with his gun, standing at one end of the car. Another lady, aged seventy-five, told of how one of the bandits pointed a gun at her and said, "Stay seated," after grabbing her bag that was around her neck. He took $50 and threw the bag into the seat. A young black female passenger told a reporter and a railroad official that she lost $2 or $3 to a bandit who struck her on the head with the pistol's butt. One woman's account noted that one of the robbers repeatedly kept saying, "I'll shoot your eye out," and "If I see a pair of eyes, I will shoot them." A male passenger who was a medical doctor described the robbery as "fantastic" and said that it took about thirty-five minutes. "The first warning I had was when a gun was pressed against the back of my head and somebody demanded, 'Give me your money or I'll shoot.'" The doctor gave up $140 to the bandits and later assisted other injured passengers and crew members.

From another male passenger's account: "The robbers stopped the train and shoved passengers in his car. Some were forced to kneel and cover their heads after their money was taken. The guns were shoved into the faces of several people with a threat, 'If you move, I'll blow your head off!' This particular passenger gave up $65 to the robbers and said they made two trips up and down the aisle."

Wire reports indicated the following: "Outside of Martinsburg, WV four bandits stopped a B&O diesel passenger train liner, slugged the engineer with a pistol, shot a dining car helper and beat an elderly woman and other passengers. They ordered crewmen and passengers alike to hand over their paper money and slugged all who hesitated. They used filthy language and threatened to blow eyes out as they moved among the fear-stricken passengers."

Duke Ashton's version from newspaper reports was as follows:

The robbery was not planned. We were sitting in the club car and we got into an argument with the steward and porter. He wanted us to settle up our bill. We were buying rounds for everyone. Our bill was $16.15 and we had the money on the train to pay for it. We didn't like a drink he had served us. The glasses for our drinks looked dirty. We went back with a porter to the baggage car to get our suitcases with

money in them. Then we held up that pesky porter. We didn't plan to hold up the rest of the people. That came on the spur of the moment. We didn't even ask each other [referring to Lu] about it. We both just started going right through cars holding up the passengers. Then we went through other cars.

Lu had forced his way into the dining car by shooting and breaking the glass in its door window. He had reached in and around the jagged broken glass to unlock the bar securing the door. Duke stayed behind but was still terrorizing all the folks in the passenger car. Chaos was rampant.

After Lu got through the dining car's door, someone quickly hit the lights. The car's main inside lights were now off. That caused immediate darkness throughout the car. Lu couldn't see clearly now, only shadows. He could hear people screaming. From the rear of the car where he was standing with his cocked pistol, Lu bellowed out, "Shut up or I'll start blasting! I have a gun." He yelled again, "Shut up or I'll shoot!" In the confusion, it was later found out that seven women, with a four-year-old, had locked themselves in the ladies toilet of the dining car. They stayed there the entire time, escaping both injury and robbery.

Suddenly, Lu sensed someone in the shadows behind him. It was one of the dining car's waiters trying to be a hero. From the back, a busboy quickly locked both his arms and hands around the front of the head bandit. He had Lu in a good lock while yelling, "I got him! I got him!" The busboy had stopped the terror for the time being. He had the bandit in his grasp. "Somebody help, I got him," he cried out. No one came to his aid. They were in darkness. Lu told this writer that if someone would have come to this busboy's aid, they would have had him cold and he would have told Duke to surrender. It was a good thing that no one else wanted to try to be a hero, too.

"Let go of me you son of a bitch," Lu said as he struggled to get free. Lu was able to twist and bump both of them around, but the waiter tightened his stronghold.

"Somebody help me! I got him!" the busboy cried out again. Still no one came to his aid. It was very dark in the dining car, and people were scared to death. Lu still had his .38 in his right hand. During the ongoing struggle, he cocked it. He could barely move or aim it, as his gun hand was pressed tightly against his right knee from the busboy's stronghold. Lu's intention was to shoot the waiter in the foot to make him let go. The waiter had his arms still lassoed in a hand lock around Lu.

Then Lu fired! The bullet missed and struck the floor of the dining car between four feet, his and the waiter's. Lu quickly cocked his piece again. He fired again! The same results transpired, but the waiter loosened his grip anyway. Lu recognized the opening for escape and sprang free. He grabbed the busboy by his front collar using his left hand. Lu cocked his pistol with his right hand and stuck it in the man's face. "Don't. Please don't," pleaded the fear-stricken busboy. He and Lu were staring directly into each other's eyes from one foot apart. They were so close that they could smell each other's breath.

Lu could have easily killed him in cold blood, but he didn't. Instead, he punched him in the stomach using his pistol as an iron knuckle. When the waiter bent over gasping in pain, Lu walloped him again, this time in the nose with the butt of his gun. The busboy fell lifeless to the darkened floor. He did not die, though, only suffering minor injuries, but Lu knew that this busboy would not bother him again.

It was time for Lu to start again, making his way in the darkness to the front of the car. He had overcome the "hero," but Lu had to get to the engine car as quickly as he could. People, in fear, were handing him their money as Lu was making his way. Lu just wanted to pass through this car's darkness.

The train was still stopped while Lu had robbed and looted this passenger car, fired shots into a glass window in a door, wrestled with a waiter, fired more shots into the floor and was now stumbling in darkness in his path to reach the next car, the party or club car. He wanted to keep moving forward to ultimately reach the engine car. The past few minutes had been a wild time, with certainly more to come, as Lu was in full intimidation mode.

The rear door of the club car was not locked, and Lu was easily able to enter it. He was still wearing the porter's cap. He entered the club car, and its occupants were still partying and boozing it up, even though the train was at a complete stop in the middle of nowhere. Most of them were so drunk that they didn't realize what was going down.

One of the drunks at the back of the car who remembered Lu from earlier approached him. Looking at Lu and seeing him wearing the porter's hat, he asked, "You working for the train now?" (The gentleman didn't see Lu's gun.)

Lu said, "Nah. I'm sticking it up."

"What?" asked a baffled drunk.

"I'm sticking it up," Lu said as he waved his .38.

"By yourself? No way. You got to be kidding."

"I got plenty of help coming up behind me."

"OK, no problem, be careful. Here, take my drink, you need it."

Lu quickly surmised that this guy was for real and said, "Thanks," as he gulped a big swallow of the mixed drink. "While I'm here I want to get me and my friend's hats we left earlier. We left them as collateral for our bar tab." Then Lu yelled out ahead to the others in the car, "This is a stickup. Give me your money," as he waved his gun for all to see. Lu did not bother the gentleman who gave him his drink. Somehow Lu knew that this guy wouldn't pose any trouble. He didn't.

The head bandit quickly snatched up more and more cash. Really no one in the club car put up any major resistance, probably because of all the alcohol they had been consuming. Lu was making his way to the front of the car, where the bar counter was located. He confronted the bartender. "I told you I'd be back. What's the damage? I want to settle me and my friend's earlier tab."

The bartender's jaw dropped wide open as he fumbled around his tab tickets to find the correct one. Upon finding it, he said, "$16.15, sir."

"Here's a twenty, keep the change. And by the way, your attitude's rotten. Your service, too," said a stern Lu.

"Sorry about that, sir, and thank you."

"Can I get our hats we left earlier as collateral?" Lu said as he could see his and Duke's zoot suit hats behind the counter.

"I have them right here, sir," as the bartender cautiously presented them to Lu.

Lu took them while taking off his porter's cap that he had been wearing. "Here, you wear mine for a while."

"Yes, sir," as the bartender put on the porter's cap on that Lu had been wearing.

"Open that damn door behind you, I gotta get to the engine car," instructed Lu to the bartender.

Meanwhile, the head engineer of the train had left his post and was working his way back to all the commotion surrounding the stoppage of his train. He was now in the club car. Without thinking and fearing for his life, the bartender blurted out, "Engine car. The engineer's right there," as he pointed toward him.

Lu turned around and said, "What! Where?"

The head engineer was easily spotted, as he was wearing his full engineer garb, including his special locomotive cap. The bartender had ratted him out, although Lu would have quickly figured it out anyway. He had found the main man he was looking for to help him further his caper.

Courtesy of the author.

As Lu quickly turned around with his .38 raised, he said, "Hey, you, come here," as he spotted the engineer only about ten feet from him. They met eye to eye.

"Huh? What?" said the engineer as he saw Lu waving his gun. The engineer soon realized what was going on: his train was being held up. Lu started stepping toward the bewildered engineer. The man did not move, as both he and Lu were near the front of the club car. Lu put his gun into his face and said, "You're going with me."

"What? Where?"

"To the engine car, and now," instructed Lu. "But first, give me your wallet." The engineer reached into his back pocket and handed it to over. Lu reached out and took it with his left hand while keeping his .38 in his right trained on the engineer's face. Lu didn't open the wallet. He put it into his own back pocket to look at later.

"Now do as I say or else," Lu said as he pressed the barrel tip of his .38 into the engineer's nose. "To the engine car, I said."

"Why? We're already stopped," questioned the engineer.

"You heard me, let's go," Lu said as he shoved the engineer toward the door. "And give me your damn cap." The engineer willfully gave it to him. Lu was now wearing the engineer's cap. This was the third different piece of headgear Lu had worn on this train—first his zoot suit hat, next the porter's cap and now the engineer's. Perhaps Lu loved hats.

Lu turned back toward the bartender, who was close by and within range of Lu's voice. "You stay right here and shut up. The rest of my gang will be here any second."

"Yes, sir," the bartender obliged. He was still wearing the porter's hat that Lu had given him.

"You did a good job of keeping up with my hats. Here, keep up with them a little bit longer," Lu said as he handed them back to the bartender. This was the second time the bartender was in charge of those zoot suit hats.

"Yes, sir, I'll have them right here for you," said the bartender as he carefully received the two hats back from Lu.

"All right, you, let's go," Lu said again as he shoved the engineer toward the door. The engineer didn't say a word as he opened the club car's front door leading to the passageway to the next car, which was another passenger car. Lu kept his piece on him at all times. Duke was still a few cars back and creating terror and dominating its frenzied occupants.

As Lu and the engineer stepped on the passageway between cars, the engineer opened the rear door of the front passenger car. As the door

creaked open, the engineer and Lu went in. Many of the passengers and occupants of the car looked back to see what was possibly going on. Lu yelled out, "This is a stickup!"

The engineer also yelled out, "Do what he says, and you'll be OK." He and Lu were now in a train car with a whole new group of people to be terrorized. Lu really wasn't interested too much in robbing them, as his pockets were crammed full from the earlier cash and loot he had lifted. His priority now was to get himself and the engineer to the main engine car. But on second thought…there's always room for more cash.

"Pull out your cash and hand it to me," Lu shouted out as he waved his .38. He shoved the engineer down the center aisle as he grabbed even more cash from the outstretched hands of some of the willing passengers. Lu didn't dillydally. He took the cash that five or six people presented to him as he and the engineer were quickly going through to get to the engine car.

As they passed down a row near the middle of the car, someone roared out, "You'll never get away with this, you sleaze ball." Lu never turned around as he kept herding the engineer forward toward the train's cab. Lu didn't confront the wisecracker.

Lu had worked his way up to the stopped train's front while manhandling the head engineer along the way. Barging into the engine's small control compartment, he quickly overtook the other engineer (or brakeman) by waving his pistol and then using the butt of it to smack him in the face. It was loud and hard to hear over the train's mighty engines even while in the idle mode. The abruptness of Lu's actions gave him full control of the engine car. Waving his .38 pistol in their faces, Lu's plan was to force the engineers to back the train up.

Lu yelled out, "Let's back this baby up!"

Standing close to Lu and only one foot from the bandit's face, the head engineer pleaded, "There's too much of a slant. The ground's not level enough. We'll tip over even if we can back up. The brakes won't hold us steady. The hill's too steep. We can't do this. No one can do this. You'll kill us all. We can't back this train up on the side of this mountain. She's only designed to back up on level ground."

Lu exclaimed, "You heard me!"

The frightened engineer paused and asked, "Since we're stopped now, why don't you jump off? You've got plenty of loot. Why not leave us be?" This ticked Lu off. He fired his .38 pistol out the window and then brought the gun back to wave it in the engineer's face. "No way. You back up this train, and now. Do what I say. Right now."

"Yes, sir," the engineer said as he started reaching for the various controls. His co-engineer and brakeman still lay dazed and bewildered on the cab's floor. As the head engineer frantically worked the train's intricate controls, fearing he'd be shot, it took him two to three minutes to get the train in the reverse mode to go back up the slanted mountainside.

After all the train's clanging and clunking sounds being generated to get it prepared to go in reverse, Lu asked the engineer, "Are you ready to back this baby up?" Lu's plan was to back up the massive diesel structure with all its passenger cars intact. He had remembered passing and seeing a lit area earlier along the rails. Maybe that area would be well-lit enough for himself and Duke to exit and to escape the train. His improvised scheme was get the train to some form of civilization, even it meant to dangerously put the train in reverse, back it up the mountain and steal a getaway car.

The moon was not out. It was pitch black in those hills. The cold March wind was whistling down the mountainside. Lu wanted to get the train backed up to an area where he and Duke could get off, a place where they could escape, to get as far away from the train as possible. They would take whatever cash, jewels, furs and other stolen goods they could carry.

It was an extremely dangerous scenario to back up the train in the complete darkness and stillness of the night. There was a good chance another train might be barreling down the tracks right behind them. The harsh, terrorized reality of a possible collision with another train ran rampant with Lu, but especially among the screaming passengers, who were now understanding the true chaos of the situation.

The train's engineers kept pleading with Lu to stop, to not do this—"You're going to get us all killed." Lu never budged from his plan. The train's head engineer begged Lu to at least let him inform their caboose-man. Lu smacked him with the butt of his pistol and told him to shut the hell up. "I've never been more serious in my life. Keep backing us up."

The struck second engineer (or brakeman) was still on the floor holding his face—no blood but a nasty bruise. The other one was standing near Lu working the train's controls and fearing for his life. He knew Lu meant business. He'd do anything Lu said. He did not want to die. He feared that Lu would shoot him and his fellow engineer.

The caboose, 150 yards back of the train's engine, was now the lead car and in charge of seeing if anything might be coming toward them. There could be another train's lights approaching. The engineer kept pleading about the possible danger. Lu finally gave permission to the front engineer to contact the caboose car by two-way radio. "Make it quick."

The engineer obliged over the communication piece, "We need to back up. We need to do it now." Lu could hear the guy from the caboose yelling over the radio: "What is going on? What is happening? Are you crazy? Why did we stop? Why are you backing up? Did a passenger fall off the train? Are you hurt? What the hell is going on? Answer me! This is crazy!"

Even Lu knew that the train could not be backed up blindly. A lookout from the caboose, the new lead car, was needed. Another train could come barreling down on them, and they needed some warning if that was about to happen. Lu's patience was stretched thin as he fired another shot from his pistol. The bullet went a few inches above the head of the other engineer who still lay dazed on the floor. The lead from the fired pistol ricocheted around the compartment but struck no one.

The head engineer was controlling the throttle and, with radio in hand, told his caboose operator, "Listen to me, and shut up. Light the emergency lanterns. Get outside on the back ramp. Keep waving them. Look out. We're backing up. We're backing up."

"What? OK, I'll do it."

"Keep the radio near your ear," instructed the head engineer. "We're backing up, for how long and how far, God help us." The caboose was now the lead car.

This horror went on for about ten miles and about twenty to twenty-five minutes. All the while, the unknown fears of backing up this massive structure took hold. Lu was wondering how much farther it could be. He opened the engine's side door and edged out onto its step, clutching his pistol in one hand with his other hand grasping a nearby handle on the engine's side. He was still wearing the engineer's cap as he was leaning, looking up the mountainside as the train was backing up. The mountain air was brisk. He finally saw some light off to the left. He yelled in to the engineer to start slowing it down. "We're about there." The engineer was glad to begin the stopping process. But bad thoughts were racing through his mind that his usefulness was coming to an end. Now, more than ever, he feared for his life and that of his co-engineer. He thought that they would soon be shot for sure. That would not happen, though—Lu was a robber, not a killer.

The massive reversing train began slowing down. It was coming near some pale lights that turned out to be a honky-tonk or roadhouse. It was a local bar located just off the tracks. The bar's dimly lit parking lot lights were the only thing Lu could see as the reversing train drew nearer to some signs of civilization. Lu kept hanging outside the train's engine looking

backward. He still had his pistol in his hand and was waving it at the engineers the whole time. Lu yelled, "A little bit farther, just a little more." They approached the parking lot.

It took a minute or two to get the train completely stopped after the engineer started applying the brakes. No doubt the frightened passengers could hear the loud, clanking, rippling noises up and down the train's connected cars. The colossal machine finally stopped a second time. It had arrived at the only well-lit place in the surrounding darkness of the West Virginia mountainside.

They had reached the tavern!

Following ten pages: Major flaws occur in the story presented by this comic: 1) Lu and Duke never called each other by name out loud during the train stoppage and robbery. 2) The bandits never went to any farmhouse. 3) The train was never backed onto any sidetrack and was always was on the main track thoroughfare. *Courtesy of Headline Comics.*

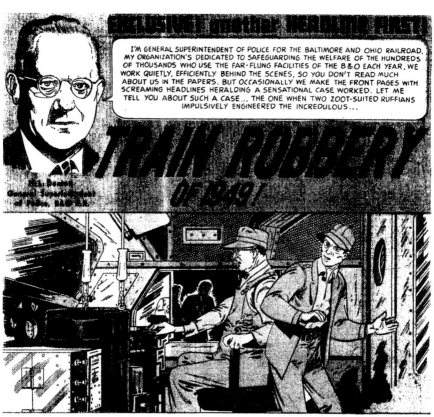

I'M GENERAL SUPERINTENDENT OF POLICE FOR THE BALTIMORE AND OHIO RAILROAD. MY ORGANIZATION'S DEDICATED TO SAFEGUARDING THE WELFARE OF THE HUNDREDS OF THOUSANDS WHO USE THE FAR-FLUNG FACILITIES OF THE B&O EACH YEAR. WE WORK QUIETLY, EFFICIENTLY BEHIND THE SCENES, SO YOU DON'T READ MUCH ABOUT US IN THE PAPERS. BUT OCCASIONALLY WE MAKE THE FRONT PAGES WITH SCREAMING HEADLINES HERALDING A SENSATIONAL CASE WORKED. LET ME TELL YOU ABOUT SUCH A CASE... THE ONE WHEN TWO ZOOT-SUITED RUFFIANS IMPULSIVELY ENGINEERED THE INCREDULOUS...

TRAIN ROBBERY OF 1949!

General Superintendent of Police, B&O R.R.

EVERY EVENING, PASSENGERS ON OUR BALTIMORE AND OHIO CRACK WASHINGTON TO DETROIT EXPRESS -- *THE AMBASSADOR* - RELAX AND ENJOY THE WILD, COLORFUL BEAUTIES OF NATURE AS THE SLEEK STREAMLINER RACES THROUGH THE RUGGED MOUNTAINS OF WEST VIRGINIA.

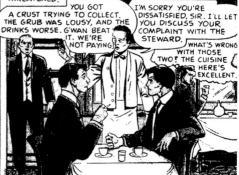

BUT ON THE EVENING OF MARCH 9, 1949, SHORTLY AFTER THE EXPRESS LEFT MARTINSBURG ABOUT 7:30 P.M., THE USUAL PEACEFUL CALM ABOARD THE TRAIN WAS THREATENED!

YOU GOT A CRUST TRYING TO COLLECT. THE GRUB WAS LOUSY, AND THE DRINKS WORSE. G'WAN BEAT IT. WE'RE NOT PAYING!

I'M SORRY YOU'RE DISSATISFIED, SIR. I'LL LET YOU DISCUSS YOUR COMPLAINT WITH THE STEWARD.

WHAT'S WRONG WITH THOSE TWO? THE CUISINE HERE'S EXCELLENT.

HEADLINE COMICS is published bi-monthly by Headline Publications, Inc., at 8 Lord St., Buffalo, N. Y. Editorial offices at 1790 Broadway, New York 19, N. Y. Single Copy, 10c. Yearly subscription (6 issues) 60c in the U.S.A. Entered as second class matter November 25, 1942, at the Post Office at Buffalo 3, N. Y., under the Act of March 3rd, 1879. Entire contents Copyrighted 1949 by Headline Publications, Inc. Vol. 5, No. 2, NOV.-DEC. 1949. Trademark Registered in U. S. Patent Office. Printed in U.S.A.

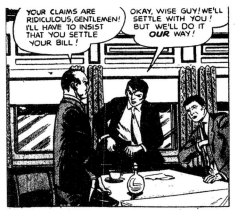

YOUR CLAIMS ARE RIDICULOUS, GENTLEMEN! I'LL HAVE TO INSIST THAT YOU SETTLE YOUR BILL!

OKAY, WISE GUY! WE'LL SETTLE WITH YOU! BUT WE'LL DO IT *OUR* WAY!

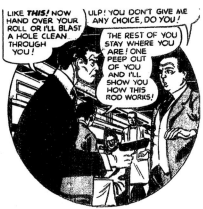

LIKE *THIS!* NOW HAND OVER YOUR ROLL OR I'LL BLAST A HOLE CLEAN THROUGH YOU!

ULP! YOU DON'T GIVE ME ANY CHOICE, DO YOU!

THE REST OF YOU STAY WHERE YOU ARE! ONE PEEP OUT OF YOU AND I'LL SHOW YOU HOW THIS ROD WORKS!

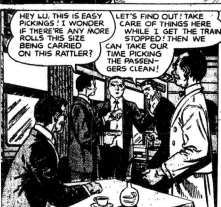

HEY LU, THIS IS EASY PICKINGS! I WONDER IF THERE'RE ANY MORE ROLLS THIS SIZE BEING CARRIED ON THIS RATTLER?

LET'S FIND OUT! TAKE CARE OF THINGS HERE WHILE I GET THE TRAIN STOPPED! THEN WE CAN TAKE OUR TIME PICKING THE PASSENGERS CLEAN!

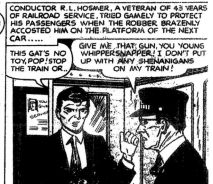

CONDUCTOR R.L. HOSMER, A VETERAN OF 43 YEARS OF RAILROAD SERVICE, TRIED GAMELY TO PROTECT HIS PASSENGERS WHEN THE ROBBER BRAZENLY ACCOSTED HIM ON THE PLATFORM OF THE NEXT CAR.....

THIS GAT'S NO TOY, POP! STOP THE TRAIN OR...

GIVE ME THAT GUN, YOU YOUNG WHIPPERSNAPPER! I DON'T PUT UP WITH ANY SHENANIGANS ON MY TRAIN!

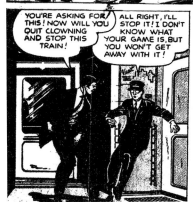

YOU'RE ASKING FOR THIS! NOW WILL YOU QUIT CLOWNING AND STOP THIS TRAIN!

ALL RIGHT, I'LL STOP IT! I DON'T KNOW WHAT YOUR GAME IS, BUT YOU WON'T GET AWAY WITH IT!

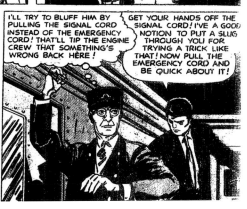

I'LL TRY TO BLUFF HIM BY PULLING THE SIGNAL CORD INSTEAD OF THE EMERGENCY CORD! THAT'LL TIP THE ENGINE CREW THAT SOMETHING'S WRONG BACK HERE!

GET YOUR HANDS OFF THE SIGNAL CORD! I'VE A GOOD NOTION TO PUT A SLUG THROUGH YOU FOR TRYING A TRICK LIKE THAT! NOW PULL THE EMERGENCY CORD AND BE QUICK ABOUT IT!

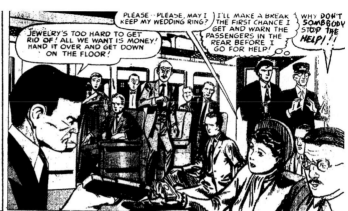

THE CONDUCTOR LOST THAT ROUND AND PULLED THE EMERGENCY CORD! AS THE TRAIN SCREECHED TO A STOP, THE DESPERADOS... LUMAN RAMSDELL AND GEORGE ASHTON... UNLEASHED A VICIOUS BRAND OF VIOLENCE AND BRUTALITY ON THEIR HELPLESS VICTIMS...

JEWELRY'S TOO HARD TO GET RID OF! ALL WE WANT IS MONEY! HAND IT OVER AND GET DOWN ON THE FLOOR!

PLEASE...PLEASE, MAY I KEEP MY WEDDING RING?

I'LL MAKE A BREAK THE FIRST CHANCE I GET AND WARN THE PASSENGERS IN THE REAR BEFORE I GO FOR HELP!

WHY DON'T SOMBBODY STOP THE HELP!!!

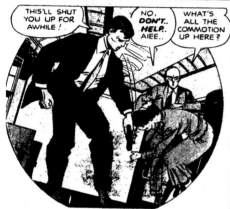

THIS'LL SHUT YOU UP FOR AWHILE!

NO, DON'T.. HELP.. AIEE..

WHAT'S ALL THE COMMOTION UP HERE?

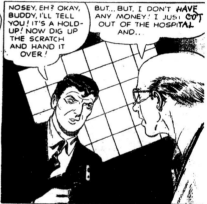

NOSEY, EH? OKAY, BUDDY, I'LL TELL YOU! IT'S A HOLD-UP! NOW DIG UP THE SCRATCH AND HAND IT OVER!

BUT...BUT, I DON'T HAVE ANY MONEY! I JUST GOT OUT OF THE HOSPITAL AND..

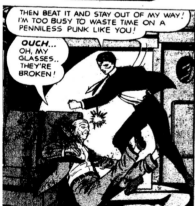

THEN BEAT IT AND STAY OUT OF MY WAY! I'M TOO BUSY TO WASTE TIME ON A PENNILESS PUNK LIKE YOU!

OUCH... OH, MY GLASSES.. THEY'RE BROKEN!

SWINGING AND SLUGGING RECKLESSLY, THE BANDITS PLUNDERED THE NEXT TWO COACHES BEFORE THEY INTERCEPTED THE ENGINEER, C.C. MOORE, WHO CAME BACK TO INVESTIGATE THE TROUBLE THAT WAS DELAYING THE TRAIN...

BUT WE CAN'T LET THE TRAIN STAND HERE! WE'RE ON THE MAIN LINE! THE NEXT TRAIN'LL CRASH INTO US BEFORE..

STOP ARGUING GET ON THE FLOOR WE'RE GIVING ORDERS HERE

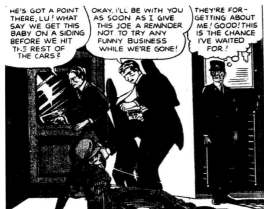

HE'S GOT A POINT THERE, LU! WHAT SAY WE GET THIS BABY ON A SIDING BEFORE WE HIT THE REST OF THE CARS?

OKAY, I'LL BE WITH YOU AS SOON AS I GIVE THIS JOE A REMINDER NOT TO TRY ANY FUNNY BUSINESS WHILE WE'RE GONE!

THEY'RE FORGETTING ABOUT ME! GOOD! THIS IS THE CHANCE I'VE WAITED FOR!

WHILE THE ROBBERS HEADED FOR THE DIESEL LOCOMOTIVE, CONDUCTOR HOSMER RUSHED BACK THROUGH THE TRAIN, WARNING THE PASSENGERS OF THE HOLDUP AND ORDERING ALL DOORS LOCKED! THEN HE RAN ACROSS A FIELD TO A FARM HOUSE AND TELEPHONED OUR MARTINSBURG OFFICE! WITHIN MINUTES, HELP WAS SPEEDING TO THE STRANDED AMBASSADOR.

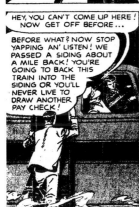

HEY, YOU CAN'T COME UP HERE! NOW GET OFF BEFORE...

BEFORE WHAT? NOW STOP YAPPING AN' LISTEN! WE PASSED A SIDING ABOUT A MILE BACK! YOU'RE GOING TO BACK THIS TRAIN INTO THE SIDING OR YOU'LL NEVER LIVE TO DRAW ANOTHER PAY CHECK!

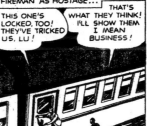

AND SO, WITH TWO PISTOLS RAMMED MENACINGLY IN HIS BACK, FIREMAN ROY PERDEW WAS FORCED TO BACK THE EXPRESS ONTO THE WARM SPRINGS SIDING! INTENT ON CONTINUING THEIR LOOTING, THE BANDITS MADE THEIR WAY TOWARD THE REAR OF THE TRAIN, TAKING THE FIREMAN AS HOSTAGE...

THIS ONE'S LOCKED, TOO! THEY'VE TRICKED US, LU!

THAT'S WHAT THEY THINK! I'LL SHOW THEM I MEAN BUSINESS!

IT WAS A WILD SHOT! THE SLUG CRASHED THROUGH THE KITCHEN WINDOW, RICOCHETED HAZARDOUSLY AROUND THE SMALL ROOM AND RIPPED SEARINGLY INTO CHEF WALTER EPPS...

DUCK, SAM, BEFORE... OW... MY LEG... I'M HIT!

KEEP THIS MUG COVERED! I'M GOING IN THROUGH THE KITCHEN DOOR!

THUS, RAMSDELL REBOARDED THE TRAIN! HE ROBBED THE CLUB CAR BEFORE HE REJOINED HIS CRONY...

COME ON, LU, LET'S SCRAM! BY NOW THE RAILROAD DICKS'LL BE WONDERING WHAT'S DELAYIN' THE TRAIN! THEY'LL BE SWARMIN' AROUND HERE LIKE FLIES BEFORE LONG!

I'M READY! AH, I SEE YOU WENT BACK FOR THE BAGS, GOOD!

GRAB THOSE BAGS AND START MOVIN'! YOU'RE COMIN' WITH US!

HAH, THAT'S CLASSY SERVICE! IT'S NOT EVERY RAILROAD THAT FURNISHES PORTERS OUT IN THE MIDDLE OF THE STICKS!

A PROMINENT PHYSICIAN MAKING THE TRIP TO DETROIT VOLUNTEERED HIS SERVICES TO HELP THE INJURED! EVEN AS THE BANDITS WERE DISAPPEARING ACROSS THE FIELD, HE WAS HARD AT WORK, ABLY ASSISTED BY OUR DINING CAR STEWARD, GEORGE GROVE...

THIS WILL EASE THE PAIN UNTIL WE CAN GET YOU TO A HOSPITAL!

OHH..DOCTOR... IT WAS AWFUL! SOB..THEY WERE SO CRUEL!

LOOK! WE ARE SAFE NOW! HELP'S COMING

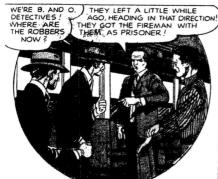

WE'RE B. AND O. DETECTIVES! WHERE ARE THE ROBBERS NOW?

THEY LEFT A LITTLE WHILE AGO, HEADING IN THAT DIRECTION! THEY GOT THE FIREMAN WITH THEM AS PRISONER!

STU AND I WILL START AFTER THEM! THE OTHERS WILL STAY AND HELP OUT UNTIL THE F.B.I. AND STATE POLICE GET HERE! THEY'RE ON THEIR WAY NOW!

KEEP A SHARP LOOKOUT! THOSE TRIGGER-HAPPY GUNMEN ARE DANGEROUS!

DON'T WORRY! WE KNOW HOW TO HANDLE PUNKS LIKE THAT!

THE DESPERATE GUNMEN, MEANWHILE, TRUDGED STEADILY BEHIND THEIR PRISONER UNTIL THEY REACHED A NEARBY TAVERN WHERE THEY CONTINUED THEIR VIOLENT ORGY...

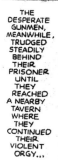

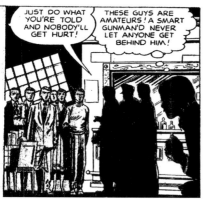

JUST DO WHAT YOU'RE TOLD AND NOBODY'LL GET HURT!

THESE GUYS ARE AMATEURS! A SMART GUNMAN'D NEVER LET ANYONE GET BEHIND HIM!

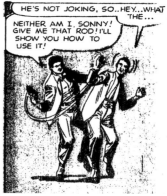

HE'S NOT JOKING, SO..HEY...WHAT THE...

NEITHER AM I, SONNY! GIVE ME THAT ROD! I'LL SHOW YOU HOW TO USE IT!

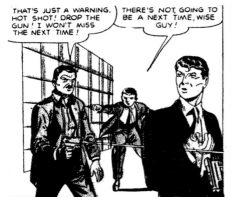

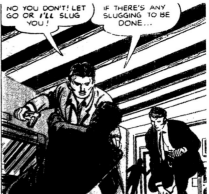

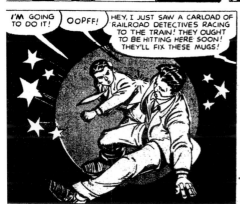

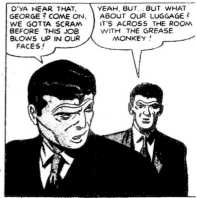

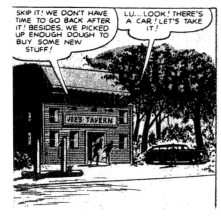

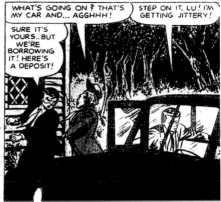

THE BANDITS DISAPPEARED INTO THE NIGHT, SPEEDING CRAZILY DOWN A LITTLE USED MOUNTAIN ROAD...

WE'LL BE HOTTER THAN A FIVE ALARM FIRE WHEN THE COPS BUST INTO OUR LUGGAGE WE DITCHED AND FIND THE PAPERS AND PICTURES WE CARRIED!

YEAH, IT WAS A TOUGH BREAK, BUT... HEY, WE'VE HIT A DEAD END! *HANG ON,* LU! I DON'T KNOW IF I CAN STOP THIS CRATE IN TIME!

WHEW! THAT WAS *CLOSE!* NOW WE'LL HAVE TO ABANDON THIS BUGGY! IT'S TOO RISKY TRYIN' TO BACKTRACK AND...

STOW THE GAB AND COME ON! WE'VE GOT TO PUT PLENTY OF DISTANCE BE TWEEN US AND THE COPS THEY'LL NEVER FIND US IN THE WOODS! IT'S OUR ONLY CHANCE!

THE FUGITIVES GUESSED RIGHT! WE DID FIND THEIR IDENTIFICATIONS IN THEIR LUGGAGE! AND EVEN AS THEY WERE FIGHTING THEIR WAY DESPERATELY THROUGH THE DENSE UNDERBRUSH, WE WERE ALERTING ALL LAW ENFORCING AGENCIES IN THREE STATES OF THEIR ESCAPE...

I'M TIRED AND THIRSTY! WE'VE BEEN TRAMPING THROUGH THESE BLASTED THICKETS FOR HOURS AND HAVEN'T SEEN A SINGLE SIGN OF A ROAD! I'M AFRAID WE... WE'RE LOST!

SO WHAT? IF WE CAN'T FIND OUR WAY OUT, THE LAW CAN'T FIND US IN HERE! ANYWAY, STOP BEEFIN', WE'RE BOUND TO HIT A ROAD, SOON!

THE ROBBERS TRUDGED DOGGEDLY ALL NIGHT, BARELY STOPPING TO REST! SHORTLY BEFORE DAWN THEIR LUCK CHANGED...

LU, WE'RE OUT! AND *LOOK,* IT'S A BUS! LET'S FLAG IT DOWN!

THAT'S A GOOD IDEA! IT'LL GIVE US A CHANCE TO FIND OUT WHERE WE ARE AN' FIGURE OUT OUR NEXT MOVE!

NOW REMEMBER, KEEP YOUR EYES PEELED! WE CAN'T RISK BEING CAUGHT NAPPING! FOR ALL WE KNOW, THIS HIGHWAY JOCKEY MAY HAVE BEEN TIPPED OFF TO BE ON THE LOOKOUT FOR US!

DON'T WORRY ABOUT ME! JUST MAKE SURE YOU KEEP YOUR BIG YAP SHUT AN' DON'T START ANY FUNNY BUSINESS! COME ON, LET'S GET IN!

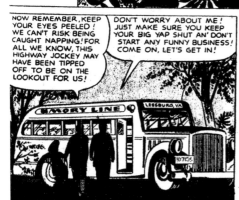

HMM... I DON'T KNOW WHY, BUT... THESE TWO LOOK MIGHTY SUSPICIOUS TO ME! MAYBE IT'S BECAUSE THEY'RE SO RAGGED AND UNKEMPT! MAYBE IT'S THE WAY THEY CHECKED OVER THE PASSENGERS WHEN THEY GOT ON! I'LL PLAY IT SAFE AND TIP OFF SPENCE. WHEN WE STOP AT BLUEMONT HE CAN CALL AHEAD AND HAVE THE SHERIFF WAITING AT LEESBURG!

AND SO, BECAUSE OF THE ALERTNESS OF THE YOUNG BUS DRIVER, BILL LOPT, THE TRAIL ALMOST ENDED WHEN THE FUGITIVES REACHED LEESBURG, VA...

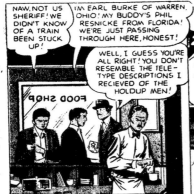

NAW, NOT US SHERIFF! WE DIDN'T KNOW OF A TRAIN BEEN STUCK UP!

I'M EARL BURKE OF WARREN, OHIO! MY BUDDY'S PHIL RESNICKE FROM FLORIDA! WE'RE JUST PASSING THROUGH HERE, HONEST!

WELL, I GUESS YOU'RE ALL RIGHT! YOU DON'T RESEMBLE THE TELE-TYPE DESCRIPTIONS I RECIEVED OF THE HOLDUP MEN!

ALL ABOARD FOR THE WASHINGTON D.C. EXPRESS!

I WONDER! MAYBE IT'S WORTH CHECKING MARTINS-BURG ON THESE TWO.... JUST IN CASE! IF THEY'RE THE ONES, WE CAN STILL NAB 'EM BEFORE THEY GET OFF THE BUS!

COME ON, CHUM, THAT'S US! IF WE MISS THIS ONE, WE'LL BE STUCK IN THIS BURG FOR HOURS!

DEPUTY SHERIFF C. FRANK REED PLAYED HIS HUNCH! THE MARTINSBURG POLICE WENT TO WORK! BY THE TIME THE FUGITIVES REACHED WASHINGTON, D.C., AT 9:30 A.M., A TRAP WAS SET FOR THEIR CAPTURE...

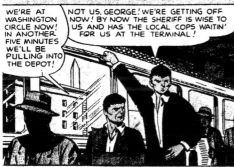

WE'RE AT WASHINGTON CIRCLE NOW! IN ANOTHER FIVE MINUTES WE'LL BE PULLING INTO THE DEPOT!

NOT US, GEORGE! WE'RE GETTING OFF NOW! BY NOW THE SHERIFF IS WISE TO US AND HAS THE LOCAL COPS WAITIN' FOR US AT THE TERMINAL!

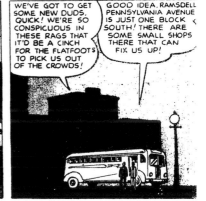

WE'VE GOT TO GET SOME NEW DUDS, QUICK! WE'RE SO CONSPICUOUS IN THESE RAGS THAT IT'D BE A CINCH FOR THE FLATFOOTS TO PICK US OUT OF THE CROWDS!

GOOD IDEA, RAMSDELL. PENNSYLVANIA AVENUE IS JUST ONE BLOCK SOUTH! THERE ARE SOME SMALL SHOPS THERE THAT CAN FIX US UP!

ONCE AGAIN RAMSDELL GUESSED CORRECTLY! A SQUAD OF WASHINGTON POLICE, LED BY CAPTAIN ROBERT MURRAY AND LIEUTENANT EDGAR SCOTT, SURROUNDED THE BUS WHEN IT REACHED THE TERMINAL...

EVERYTHING'S ALL RIGHT, FOLKS! JUST KEEP YOUR SEATS UNTIL WE'VE HAD A CHANCE TO PICK OUT THE TWO BOYS WE'RE INTERESTED IN!

IF YOU'RE LOOKING FOR TWO YOUNG MEN WHO WERE SHABBILY DRESSED, CAPTAIN, YOU'RE TOO LATE! THEY GOT OFF NEAR WASHINGTON CIRCLE!

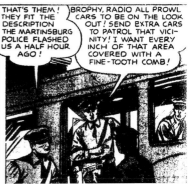

THAT'S THEM! THEY FIT THE DESCRIPTION THE MARTINSBURG POLICE FLASHED US A HALF HOUR AGO!

BROPHY, RADIO ALL PROWL CARS TO BE ON THE LOOK OUT! SEND EXTRA CARS TO PATROL THAT VICI-NITY! I WANT EVERY INCH OF THAT AREA COVERED WITH A FINE-TOOTH COMB!

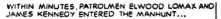
WITHIN MINUTES, PATROLMEN ELWOOD LOMAX AND JAMES KENNEDY ENTERED THE MANHUNT...

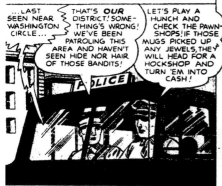

...LAST SEEN NEAR WASHINGTON CIRCLE...

THAT'S *OUR* DISTRICT! SOMETHING'S WRONG! WE'VE BEEN PATROLING THIS AREA AND HAVEN'T SEEN HIDE NOR HAIR OF THOSE BANDITS!

LET'S PLAY A HUNCH AND CHECK THE PAWN-SHOPS! IF THOSE MUGS PICKED UP ANY JEWELS, THEY WILL HEAD FOR A HOCKSHOP AND TURN 'EM INTO CASH!

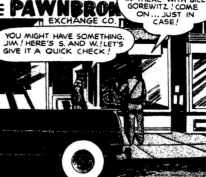

ELWOOD, LOOK! THERE'S SOMEONE IN THERE WITH BILL GOREWITZ! COME ON... JUST IN CASE!

YOU MIGHT HAVE SOMETHING, JIM! HERE'S S. AND W.! LET'S GIVE IT A QUICK CHECK!

S&W PAWNBROKER EXCHANGE CO.

THE OFFICERS CALMLY ENTERED THE STORE AND IMMEDIATELY CHALLENGED THE SUSPECTS...

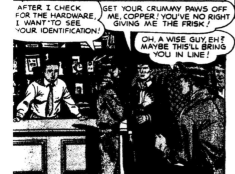

AFTER I CHECK FOR THE HARDWARE, I WANT TO SEE YOUR IDENTIFICATION!

GET YOUR CRUMMY PAWS OFF ME, COPPER! YOU'VE NO RIGHT GIVING ME THE FRISK!

OH, A WISE GUY, EH? MAYBE THIS'LL BRING YOU IN LINE!

NOW ARE YOU GOING TO BE GOOD OR DO I HAVE TO GET REAL TOUGH WITH YOU?

OOFF!

I'LL GET YOU FOR THAT! NO BLASTED COP BELTS ME AND LIVES TO BRAG ABOUT IT!

LOOK OUT, WOODY! HE'S DRAWING A GUN!

MAYBE THIS'LL GIVE WOODY A CHANCE TO BEAT THAT MURDER-BENT THUG TO THE DRAW!

Bar Robbery of Fifty People

The music will stop when you fire off a few shots from your .38.
—Luman Ramsdell

As the train had been backed up to this clearing possessing little light, and with the mighty diesel vessel stopped for a second time, Lu dragged the head engineer out of the engine car. The bandit grasped the back of the engineer's work suit's collar and told the brakeman to stay put in the engine compartment—or else his partner would get it. The head engineer lost his footing due to Lu's forcefulness. Only a few feet out of the engine car, Lu smacked the engineer again with his pistol but left him alive in the brush just off the train's tracks. The engineer remained very groggy in the bushes, as Lu didn't think he'd pose any further trouble.

Lu needed to find Duke, who was somewhere back among the passenger cars. Duke was meanwhile busily getting his and Lu's suitcases and all the loot he could carry. When the train stopped, Duke tossed their luggage pieces out, along with stolen fur pieces from the second passenger car back. His pockets were full of stolen cash, rings, watches and necklaces. Duke was like a walking jewelry store full of stolen items.

A handful of passengers started jumping off. Most did not, staying inside the train. There was confusion everywhere. The train had been backing up and was now stopped a second time, and both times were unscheduled. People still feared for their lives. The air was filled with uncertainty.

After jettisoning their suitcases and the collected loot, Duke jumped down from the train and yelled for Lu in the dimly lit area. Lu recognized that

it was him and began making his way in his direction. "Come on. That must be a bar there," Lu said as he nodded his head in the direction of the building. We're going inside. We gotta get some keys. We need a car."

More and more people were getting off the train. They thought it safer to be off the train than on it. They likely thought that they, too, could get help in the confusion. Duke asked, "What are we going to do with all our stuff? There's a lot of it."

As more people gradually continued to get off the train, they were bewildered and scared in the darkness. Lu compared them to zombies moping around. Some sat down on the ground. Women were crying. Men were mad. Lu and Duke both realized that they didn't have much time. The passengers and train personnel would soon figure it out that the entire gang was composed of only two men. The two bandits were going to lose control of the situation.

It was now nearing midevening the day of the train robbery as Lu and Duke got off the stopped train. They decided that their course of action, escape, required a getaway car. Aware that coppers and authorities would soon be closing in, the bandits had no desire to be recognized or spoken to by strangers. They needed a vehicle and quick!

The parking lot of the Clover Rail Tavern was dirt. (Some accounts called it Joe's Tavern.) It was dusty. Trash, paper cups, cigarette butts and empty beer bottles were strewn about. Three smoking fifty-gallon drums were off to one side. They were being used to burn dry trash. There was a burnt smell in the air, and the smoky trash produced a haze within the parking lot. That, combined with the surrounding fog of the mountainous area, made it difficult on one's field of vision. Patrons' cars and pickup trucks were parked in random order. There were no designated parking places. A rope was strung across one end of the lot to show a sharp drop-off down the mountainside. There were about six cars and a dozen trucks. It was midweek party time on a Wednesday night, March 9, 1949.

Although not that big of a place, about twenty by forty feet, the bar was packed with locals dancing and drinking. They were all carrying on and having a good time. The bar was filled with smoke. A loud country western band was banging and singing away from a makeshift stage at the back. The locals were used to hearing trains go by, as the front door of the bar was only about three hundred feet from the main tracks. Those types of sounds were commonplace. They didn't realize on this night that a train had just backed up to their door, let alone one that had just been robbed.

No one in the bar knew what had just happened regarding the train stoppage and robbery. They had been drinking and partying while enjoying the loud music. They didn't know that a 150-passenger train had been terrorized, robbed, stopped and backed up to their door. It was a typical fun night for them at their local tavern. Perhaps the train at their front door had only broken down. They didn't know.

Lu helped Duke carry their suitcases and the newly acquired and varied loot from the train's passengers. The bandits tossed all their stuff just outside the bar's front door, plopping things down on its makeshift little porch. Lu also pitched off his engineer's cap onto some shiny jewelry on the top of the suitcases. He didn't want to enter the bar with an engineer's cap on his head.

An anxious Lu said to Duke, "Let's go in. Be waving your piece, but be cool. We just need some keys for a getaway car. That's all we want. Shouldn't take us long." The entrance to the bar wasn't a wide door. Lu went in first, with Duke right behind him. Lu had his .38 and Duke his army automatic .45. As soon as they got one foot inside and without hesitation, Lu fired his pistol into the floor. It was an old rickety wooden floor through which the bullet easily passed. The sound of the discharge made everyone look in Lu's direction, but the band still blared away. Lu fired another shot. By this time, Duke was by Lu's side instead of behind him. Duke did not fire his .45, but he was waving it around for the horrified crowd to see.

The music did stop, and suddenly there was complete silence in the bar. It wasn't that big of a place with the country music band set up at the back end. About fifty people total. The whole place went deadly quiet. The bandits meant serious business, and everyone there realized it. They were stunned. A waitress dropped her tray full of drinks. Another quickly sat down at a table with patrons. People were gasping.

When Lu and Duke went in, their only intention was to get some keys to steal a quick getaway vehicle. They had no intention of shooting anyone, but the folks inside did not know that. Lu and Duke needed a way to flee from the area, to get as far away from the train as possible. They wanted some car keys right away. Lu and Duke had no plans to rob these folks the way they had robbed

Courtesy of the author.

passengers on the train. The bandits exercised extreme caution, as they thought that some of the bar patrons might be armed themselves.

After Lu fired those shots into the floor, everyone froze in fear. Lu bellowed out, "I need keys, car keys. Car keys!" No one spoke up. No response from the bar's customers. They were too scared, too dazed and too shocked to speak. Some were in the bathrooms not knowing what was happening.

Lu got really upset that no one spoke up to volunteer a set of keys. Lu yelled in a louder, sterner voice, "Everyone hit the floor! Facedown! And now!…Facedown! Everybody hit the floor! Everybody down!" He fired another shot, this time into the bar's ceiling. Particles and plaster pieces twinkled down from above Lu's head. He started waving the gun back and forth across the crowd. Women were screaming. Men were breathless.

This time, everyone did drop to the floor lying facedown, but there was more concern from Lu. He was thinking that the owner behind the bar probably had a weapon of some sort, maybe a double-barreled shotgun. "Duke, quick, check out behind the bar! There may be a shotgun!" Duke did but found no weapon. Duke was also thinking that the folks in the bathrooms might have been armed and motioned to Lu while saying, "The toilet… Yea, Duke, get anybody out of there and out here." Duke quickly herded the four or five who were in both bathrooms out into the middle of the bar. Lu and Duke now had full, terrorized control of the honky-tonk. They had everyone's undivided attention. Lu was near the door at the front of the bar. Duke was about halfway in the middle against a wall covering his back. Both bandits were flagrantly brandishing their weapons. They were ready to fire if anyone tried anything suspicious.

With fifty or so people on the floor facedown, and with Lu and Duke walking around and stepping over them, Lu yelled, "We're now gonna come around and start searching pockets. The first set of keys we find, that person will get a bullet in his ear!"

Duke also yelled, "You heard him, a bullet in your ear! Who's first? I'm ready to shoot!"

The bandits needed keys. They didn't really want to hurt anyone in the bar. By now, Duke was separating and moving himself farther from Lu to cover more patrons. "Hey, Lu, want a drink?" as he went toward the bar counter waving his .45 in the barkeep's face. "A couple straight-up whiskeys, please, and a bottle for the road." The barkeeper, who also was the owner, nervously poured a couple shots from a new bottle. He was spilling whiskey as he poured. Duke immediately downed both shots and said, "Lu, I'm bringing the bottle along for you."

Lu yelled out again, "Bullet in your ear. Keys! And I mean now!"

Almost simultaneously to the sound of the bandit's crazed voice, about twenty people on their bellies instantly started reaching into their pockets and purses. They started tossing keys with backhanded motions into Lu's direction. Lu later described it as cartoon-like, as he had to duck and dodge to keep from being struck by so many keys coming into his direction at once. Some were being gently tossed, while others were coming at Lu as fast as baseballs being thrown at a carnie milk bottle attraction.

Duke started laughing at Lu from the other side of the room and yelled, "Hey, you asked for it! They're doing what you said." Duke got a kick out of his partner having to duck and dodge. Lu never got struck by any of the keys coming his way, though. Some of the keys bounced off the back of the wall behind Lu.

One of the last tosses was from the front, where the patrons were lying on the floor. Lu saw exactly who tossed it and, upon making a catch with his free hand, the one not holding his .38, said, "OK, you. On your feet." It was a pretty young redhead in her mid-twenties wearing a black dress.

Lu said, "These are your keys. Get up. Come here, point out your car." She hesitantly rose from the floor. At gunpoint and at Lu's instructions, she followed him outside on the porch. Duke was backing his way out of the bar with his .45 raised, ready to fire. He, too, was exiting the roadhouse.

The redhead said, "It's right there, the second one on the right," as she motioned to her vehicle. Duke was following right behind them. Now all three were on the porch and could see the figure-like shadows of people wandering around in the parking lot, the ones still in a daze who had gotten off the train.

"Good. Here's a fin [five-dollar bill], pretty lady. Go back in and get yourself a drink…On me." Lu winked at her. Hesitantly she took it but then quickly turned and went back inside clutching the bill. Lu and Duke looked around the porch searching for things they had left there upon entering the establishment. Lu instructed Duke, "Help me gather up what bags and suitcases we can. Get those furs. Get the jewelry, too. Get as much of our stuff as we can. I'll help you, but keep a sharp eye out." They knew that those in the bar who may have been possibly armed would be bursting out the door any second coming after them. The bandits made their way toward the vehicle they were stealing.

Duke was still chuckling about Lu's actions. "Gave her a fin, eh? She's probably single, too?" Lu did not respond. The bandits quickly got into the car. It was a black four-door Ford sedan, nothing fancy.

It started right up.

CHAPTER 7

Identified at the Diner

I got your ID right here, officer.
—Luman Ramsdell

Upon leaving the honky-tonk's porch of the Clover Rail Tavern, Lu and Duke quickly got into the vehicle. Its doors were not locked, and the bandits now had its keys. The vehicle started right up, with Duke behind the wheel and Lu in the passenger side.

It had only taken the bandits less than five frantic minutes to go into the bar, fire some shots, frighten everyone and get what they needed. There was uncertainty everywhere. More of the train's passengers were beginning to get off into the roadhouse's dirt parking lot. Many of them were stumbling around the shadowy darkness in fear, trying to figure out what was happening and what had happened.

"Look at 'em. They look like zombies moping around. Let's get going, Duke. Don't run over any of them. Drive us out of here, Duke. Let's go!" exclaimed Lu. From the passenger side, Lu was hurriedly reloading his .38 pistol, making sure that all its chambers were full. Duke had not yet fired a shot while helping rob the train and the bar. His army automatic's .45 clip remained almost full. Duke revved up the car's engine and drove them quickly to the front of the parking lot's entrance. It was a dirt road that ran parallel to the train tracks.

"Up or down? Which way, Lu? Do we follow this back up the mountain or go down it?"

"Let's go up. They'll be expecting us to go down."

"OK," Duke said as he floored the gas pedal. He kept flicking and feeling with his foot against the floorboard, trying to find the car's headlight dimmer switch. (In that era, the switch was a metal button or knob about one inch in diameter and height and located to the left of the driver's foot.) After a few tries of clicking with his foot, Duke got the car's headlight beams on high. Now they could speed away to freedom. Up the road they went. After only one-fourth of a mile of traveling on the dirt road, Duke said, "Something's wrong with the engine. It's acting up."

The vehicle started coughing, and the car abruptly stopped. They were out of gas. The bandits had picked the one vehicle that didn't have much gas in its tank. Of all the luck. Cool-headed Lu said, "Get out. Back to the bar. We've got to get another car. It ain't that far." He and Duke both got out of the vehicle.

"Just a minute, Lu," Duke said calmly as he reached for his gun. Without hesitation, he fired and emptied the entire clip of his pistol into the car's body. He aimed for the vehicle's lights but kept missing. The army .45 pistol's shots echoed in the night air off the mountaintops. "Take that, you piece of crap!"

Lu was dumfounded but started laughing. "Think you got him, Duke? Come on, we gotta get back, get another car. Let's go. Back to the bar lot. But first help me put all our stuff behind some bushes. We'll come back by to get the loot. Come on, let's get to it. We may have to have another drink while we're there, too. You got another clip for your .45?"

"Yea," Duke said as he reached into his pants pocket and reloaded. He had earlier taken a clip out from one of his and Lu's suitcases.

Lu said, "Yep, get loaded up. Be ready. I am. We gotta go back. We didn't get all our stuff we left on the porch."

In their hasty confusion, they had spun out of the parking lot the first time without all their suitcases, leaving some of the loot from the train. It only took them six to seven minutes to return back to the honky-tonk on foot. They were again going to the place they had robbed only a few hectic moments before. Their guns were fully loaded and ready to fire.

Upon arriving at the parking lot their second time, they were out of breath. The area was filled with people, ones from the train and ones from the bar. The parking lot seemed mighty full, but there were no coppers in sight. Someone in the haze recognized the bandits and immediately yelled out, "It's them! They're back!"

Everyone started scattering. Lu and Duke paid no mind. They only wanted two things: the rest of their loot and another getaway car. The

bandits were making their way to the bar's entrance when they made a surprising discovery. Some of the bar patrons had been going through a couple of Lu and Duke's suitcases that they had left on the porch. The prowling patrons had taken some of the bandits' things, including part of the loot from the train. Clothes, cash, jewelry and furs were scattered around the porch and on its railing. The bar patrons had made a mess rambling through Lu and Duke's stuff.

Lu murmured to Duke, "God almighty, look at that. Those drunk, dirty buzzards! Those bastards!" The train robbers had been robbed themselves—perhaps poetic justice. Lu and Duke thought about firing their weapons but backed off. "I'm going inside. You stay here. You deal with them. Stay on guard. I won't be long," Lu instructed Duke. Lu really thought that Duke would soon be dealing lead and discharging a few rounds from his .45.

Duke bellowed, "I'm going to shoot somebody. You drunk bastards!"

People quickly scampered off the porch, but Duke never fired. Lu burst in through the bar's narrow front door. He fired two shots at the light fixtures overhead. He missed the bulbs but got everyone's attention—for the second time. "Yes, I'm back and need another set of car keys. Now! And I mean right now," as he waved his pistol back and forth pointing at the crowd.

Someone yelled, "Why don't you leave us alone?" From a group of ladies and without hesitation, one spoke up. She was in her mid-fifties and pretty well intoxicated. "Here, take these. They're to my boyfriend's car. He's parked right out front. I'll show you!"

"You're damn right you'll show me. Good, come on, go with me," said Lu in a very stern manner.

"But I don't want to go with you. I've given you the keys. I don't want trouble. Please, no."

"Lady, shut up and come on," Lu said as he grabbed her arm, pulling her out onto the porch as his other hand was waving his .38.

Duke saw them coming out. Lu tossed Duke the keys. "OK, dame, which car?"

She pointed it out to Duke, "That one. That one right there."

Lu said, "Duke, make sure it's the right car. Start her up and grab up all our loot you can. Throw it in the back seat." Lu was still holding on to the lady's arm. "I'm taking her back inside." The head bandit whisked her back into the bar and threw her down on the floor. She wasn't hurt but was still very afraid. She also started throwing up. Lu yelled over to the bar owner, "I forgot my bottle of whiskey!"

The bar owner said, "Sure. Here, take two while we're at it."

Lu quickly grabbed the bottles and made his way back to Duke to their second getaway car. It pretty much looked like the first car they had stolen. It, too, was a plain dark-colored sedan. Duke had jumped into the driver's side, started the vehicle and was anxiously waiting for Lu to join him. He had stashed their ransacked suitcases in the car's backseat and whatever other stolen loot from the train he could—some furs, necklaces, watches and money. Some of the train cash had been stolen by three or four of the bar patrons when they went through Lu and Duke's things on the porch.

All of a sudden, the car owner, the lady's boyfriend, jumped in the front car seat with Duke! The rightful owner had his own pistol and started waving it directly into Duke's face. Duke knew his life was over. He thought this guy was going to shoot him dead behind the steering wheel. The car owner was probably thinking, *This'll teach this S.O.B. to steal my car.*

Lu was only seconds behind Duke as he left the shocked honky-tonk patrons. The car's windows were down. Lu abruptly appeared outside on the passenger side. Upon seeing Lu, the car owner, with pistol in Duke's face, became startled. He quickly gazed at Lu through the car's open window. That split second of turning toward Lu was Duke's chance to act, perhaps to save his and Lu's lives. Without thinking, Duke walloped the guy upside the head with the butt of his army .45. The blunt force of Duke's blow stunned and injured the guy to the point of unconsciousness. It was a sharp, quick blow. Lu quickly opened the passenger-side door and jerked the guy by the collar onto the dusty, dark ground. Lu left him lying there and, at this point, didn't give a rat's ass about him. (The guy would fully recover later, nothing serious.) The scene was chaotic as Lu jumped inside the vehicle. The people in the parking lot didn't know what to think. They realized, though, that another tragic commotion was taking place.

With yet another hopeful getaway car, off the bandits went, speeding away. They quickly came upon their earlier ditched and shot-up vehicle and pulled over next to it. "Duke, quick, grab our stuff behind the bushes!" He quickly obliged, jumped out of the vehicle and pushed the bushes back using the car's headlights to help see. Lu was right behind him and helping. They both got scratched about their faces and heads as they were frantically throwing bags and loot into their second getaway car, which they had left running. Then they sped away.

Within minutes, they quickly reached a main thoroughfare, this one paved, only a few miles out from where they had just left. Upon turning left onto it, they could see reflections of flashing lights and hear sirens in the distance.

"What's all those flashing lights coming right at us?" Duke asked of Lu.

"Coppers! Dozens of 'em! Keep cool. Keep driving," Lu responded.

They were meeting cop cars in the oncoming lane that were rushing to the crime scene. Duke and Lu were in one lane going one way and the police in the other lane going another. Calmly, Duke kept driving, watching cop car after cop car going the other way in the oncoming traffic. They met at least six cop cars not spaced too far apart. A couple of coppers on choppers, too.

Duke looked over to Lu, saying, "Man, what a commotion we've stirred up. Look at all these coppers."

Lu didn't utter a word, but he took a stiff drink of whiskey straight from the bottle he had brought from the roadhouse. "Keep driving. Keep your eye on the road. We've got a little time. They're all heading the other way. Drive!"

Someone at the bar had tipped off the police, most likely its owner. Or perhaps the train's short-wave radio had been used to call the authorities. In the oncoming traffic, the bandits were meeting at least half a dozen or more police cars and motorcycles. After they'd met about the fifth car, Lu told Duke that they'd quickly figure out who they were. "We can't go on in this car. We got to do something else. They'll catch us for sure," exclaimed Lu. "Quick, look for somewhere to ditch this ride!"

The bandits had only gone a few more hundred feet when Duke saw a little side pass in the car's headlight beams off to the right. "This is as good a place as any," Duke said quietly as he took it. He pulled the car off the main road and then drove it around and parked the car up under the train trestle. It was a good hiding place up under the tracks. The bandits left the vehicle and grabbed what goods and stolen loot they could. They carried things in both hands. The bandits pushed their pistols down into their pants in the smalls of their backs. They set out on foot. They left ransacked suitcases, as they couldn't carry them all. Each took one suitcase. It was dark, and they feared that they might be soon captured. They had to get moving.

Their best bet was to follow and walk on the train tracks. It was too dangerous to walk along the main road, as they'd be easily spotted. Lu thought that this was very wise, as the coppers would be looking for them in the car. There would certainly be roadblocks set up all around the area. All the roads would be covered. They'd walk on the train tracks. They could make their way along them, as the path on the tracks could be followed in the darkness. Their strategy was to keep moving even on foot. Lu and Duke could still hear police sirens in the distance. Bushes, limbs and briars kept hitting them in the face as they briskly walked the tracks, trying to get as far away as possible. Their pants were becoming jagged from branches and briars.

Hours passed as the loaded-down bandits walked the rails for miles. The siren sounds started to dwindle. They dared not slow down, as that would mean certain capture. They had to keep moving, even though they were getting pretty bruised and scratched up from the miles of walking the rails in darkness. Drudging suitcases and stolen goods was tiring. They could hear dogs barking—not police bloodhounds but rather dogs from nearby farmhouses they were passing that were located just off the tracks.

The bandits kept walking, hoping to possibly hitch a ride on a freight train on one of the sidetracks they were encountering. Twice, a very slow train came by, but it was impossible to grab and jump on board even though Lu and Duke got real close. Lu told this writer:

> Hey, don't believe all you see in the movies. Trains with tons of metal and moving parts of steel are extremely dangerous. We had the nerve to rob and bully people, but it takes a daredevil with nerves of steel to grab on a moving train. We couldn't do it. We tried and gave up. We kept on walking and talking. We buried some money and jewelry, memorizing where it was. By the tracks, a water tower and a big, big tree. That was 1949. Two days later, I had no idea where I had buried the money. Sixty something odd years later, it's still there. Maybe we can take a road trip back up there. The gold in the jewelry and watches would be worth a lot today. That water tower may be still a marker. Just a passing thought. I remember it better now than in those drunken days of 1949. Duke and I bumbled by farm pastures. Dogs barked when we approached farmhouses.

The two men finally came to a clearing. They could look down from the raised ground of the railroad tracks. They could see some lights. It was a bus stop station, a hub of some sort. It was small, but they could see that it did have a roadside diner. There were a few buses under a shed, probably being worked on. No other buses were in the lot. The bandits were about eight to ten miles from the honky-tonk and the train that they had backed up. They had made most of their getaway on foot walking the train rails. They were both bleeding from the briars that kept slapping across their bodies and pant legs. The prodding through the darkness had really taken an exhausting toll on the bandits. They decided to leave the train track to go down to the small bus station.

"Let's case the joint before we go in," Lu instructed Duke. "Let's check out the lay of the land first. Let's see if anything is going on. Let's walk around a little down there." Both bandits were tired and beat up. They

looked rough. They had been through a lot in the last few hours. The bus station's parking lot was dirt, same as the earlier honky-tonk's. It was dusty and not that well lit, with just a few streetlamps at each end. Lu and Duke were moping around carrying their suitcases when a person of authority approached them. It was the bus depot's manager.

"What happened to you boys? Did a bus just drop you off?"

Lu said, "No, we've been walking. Walking for miles. We were in a car wreck awhile back and lucky to be alive. We just need to catch the next bus to get some help." Lu never made direct eye contact with the gentleman. "When is the next bus?"

"To where? Where do you boys need to go?"

"D.C. The D.C area." Even disoriented and exhausted, Lu, as leader, always kept his wits. He was thinking that perhaps a bus out of there going anywhere would work. It was their only option. He and Duke were exhausted, and they couldn't walk anymore. To get to Washington, D.C., a big town, sounded good. They could blend into the crowds and maybe go visit the president while they were there. Lu thought that they were invincible and could do anything they pleased—even get to the president of the United States of America. They were on a roll, so why not?

Lu and Duke stepped away from the bus depot manager to further think about their next move. The attendant said that it'd be an hour or so before the next bus, but Lu suspected that the guy wasn't buying their story.

"Better go purchase your tickets," said the manager.

"Yes, sir. Where's the ticket counter?"

"Just right over there. Ring the bell. Someone's in the back that'll come out and help you." The bandits calmly took a few steps to the ticket window and purchased two one-way D.C. tickets. They paid with cash.

"Thank you, gents. It'll be about an hour before your bus arrives," the ticket clerk explained. "You might want to hang out in our diner." News of the train robbery had not reached the bus station. With an hour or so to kill and no other options but to wait for the next bus, Lu and Duke went into the little diner, which was part of the small bus station. It was a short-order café with a counter. It had six round stools and four booths. The stools were fastened to the floor and had no backs but could pivot around. It wasn't that clean of a place, with dirty glass windows and a glass door with a push-and-pull bar. The diner was dusty inside and out from all the pulling in and out of the buses at the depot. Travelers and passengers used the place mainly to get hot coffee while waiting for their scheduled buses.

Courtesy of the author.

Lu and Duke sat down at the counter but not next to each other. There was an empty stool between them. They both ordered black coffee. There was no one else in the diner besides Lu, Duke and a male waiter who was also the cook. The sole help was taking a drag off a cigarette and wearing an apron.

Meanwhile, the bus depot manager had spoken to a sheriff's deputy who just happened to already be in the bus depot. His presence there was just routine duty. The deputy was young, a greenhorn, and alone with no backup. He was in full uniform. The manager tipped him off about the two characters who looked pretty rough and suspicious of something—just what, he didn't know.

The young deputy carefully entered the diner. His weapon was not drawn. He was checking things out, simply being inquisitive. He had not heard about the train heist or the bar robbery only a few miles away. He was only going to speak to the suspicious patrons at the café's stool counter.

The law officer slowly walked to the empty stool between Lu and Duke. He reached down and gave it a gentle swirl. It squeaked a little. Lu put his hand around his back, near his hidden pistol. Duke did the same. The bandits

were keeping their cool and looked into the deputy's direction, making quick eye contact. The deputy calmly sat down on the barstool in between Lu and Duke. He only wanted to speak to the men without fully confronting them. He had no idea who they were or what they had just done.

A super-cool Lu addressed the deputy, "Sit down, have some coffee."

"How you boys doing?" asked the officer.

"Just tired and beat up. We were in a car wreck a few miles over. Just waitin' on the bus to get home and some help."

"Where was the wreck? How did it happen? Anybody else involved?"

Lu spoke up, "Nah, it was just us. Very dark when we ran off the road. Kept from hitting a deer, a rabbit or something. We lost control and wrapped our car around a tree after flipping a couple times. We were very lucky not to get more seriously hurt."

"You from these parts? You boys have some ID? Some form of identification?" asked the deputy.

"No, we're from Ohio," Lu said as he looked him straight in the eye and, without further thinking, whipped out a wallet he had in his back pocket. The deputy was carefully watching Lu the whole time. Lu needed to immediately please the deputy and follow his requests.

Duke spoke up and said, 'I must have lost mine in the wreck. Hope I can find it later." The deputy gazed over toward Duke as he spoke and then turned and looked back at Lu.

"I got your ID right here, officer." In his haste to appease the law officer, though, Lu had pulled out the wrong wallet. It was the train engineer's instead, the one he had lifted and robbed earlier. Lu caught his mistake to himself but didn't utter a word. He carefully started taking some ID papers out. Lu handed the identification certificates to the deputy. There were no picture IDs in 1949.

The deputy looked the ID papers over and could see Lu's pistol packed in his belt. Without incident, the deputy calmly gave Lu the wallet back and said, "You boys enjoy your coffee." Then he carefully exited the diner. He was doing the right thing. Lu would have dropped him if he hadn't. He knew he could outdraw him. And besides that, there were two of them. He had Duke he could count on if needed.

The deputy went about his way unharmed. He carefully went to a phone in the bus station, one that wasn't in the diner, and made the call to his headquarters.

Lu and Duke finished their coffee.

Avoiding Blockade

A six-thousand-strong law enforcement manhunt
looking in the wrong trains and up the mountainsides.

One newspaper described the train heist as follows: "Jesse James and his western cronies would have been proud of the technique. The raid netted as much as some of the Missouri gang's forays except when they happened upon a money shipment in the express car." Another account stated, "Some officers thought this job was pulled by drunken amateurs. The victims were so dazed they couldn't tell exactly what happened." While another noted, "Young bank robbers on the lam evaded manhunt of 6,000 for several hours. The desperados were well beyond their years in well executed plan and escape routes." Planned or not, the robbery was spectacular as it topped the headlines across the nation's major newspapers.

After the deputy exited the diner and the bandits finished their coffee, Lu told Duke, "Time to go." Lu laid down a one-dollar bill to cover his and Duke's coffees.

The guy behind the counter asked, "Change?"

"Nah, keep it," said Lu in a nonchalant kind of way. The guy thought it was an awfully big tip for two cups of joe at a nickel apiece, but he took it and bid them on their way. "Be careful. It's a jungle out there."

"Yea, tell me about it," said Duke. Lu chuckled under his breath. Lu and Duke grabbed their two suitcases that they had left at the front of the diner. The suitcases were on a rack tray designed as an area for patrons

to place their bags while eating. Lu's and Duke's pockets were still full of cash and a few odds and ends of jewelry from the heists of the train and tavern. They had a few furs sticking out of one of the suitcases. Their other suitcases, satchels and looted items were now lost and could have been strewn anywhere—among the train, the tavern parking lot, the getaway cars and the railway tracks on which they had been walking. At best, the bandits had half of their original stolen loot.

They couldn't wait for the scheduled D.C. bus for which they had purchased tickets. It was too risky to hang around. They had to get moving again. With each having a suitcase under his arm, Lu said, "Let's start walking. Maybe we'll meet a bus and flag it down. We can exchange our tickets if we need to or buy new ones with cash. We gotta get away from here. That copper has phoned it in. I know it! He'll be back on us real quick. We gotta get moving to get on a bus—any bus. We can't wait around here anymore near this depot. They'll surely come looking for us here."

"Sure, let's go. Good idea," said Duke. There were four to five roads leading out of the bus depot—some were paved and some not. The bus depot was the hub of an intersection that broke up the stillness and monotony of the forests and hills all around.

"One's as good as the next," Lu consoled as they started off. They took one of the dirt roads, thinking that the coppers would probably be covering the paved one, as well as more important thoroughfares. It was early morning, near daylight. Lu and Duke could see a little as they were making their way on foot. They were exhausted as they had been up all night, walking the rails. The bandits were hung over, had headaches and were irritable. Lu was hoping that soon they'd meet a bus on the dirt road they were taking. Maybe they'd have some more luck, as they seemed to be catching an abundant amount of good breaks the past few hours.

The bandits had only been walking a few minutes when they neared yet another a small intersection. This one had a small garage. There were three or four junk cars in its yard. They could hear an engine in the distance. "If it's a bus, we'll flag her down," Lu instructed Duke. "It'll have to be a bus. We'll stop her and hitch a ride."

"Yes, maybe a bus," said Duke. The engine sounds were growing louder. They had not seen or encountered any other vehicles during their quest to escape. It did turn out to be a bus. Lu and Duke flagged it down and then boarded the Greyhound.

A newspaper account noted:

It was early Thursday morning March 10, 1949. The driver of the oncoming bus had heard a radio broadcast the night before about the train robbery. From later reports he had told his wife at home that it would be "funny" if the robbers decided to take his bus to Leesburg (VA) to make a perfect getaway. The following morning [that Thursday] *he left Martinsburg (WV) with two regular riders who were going to Charles Town (WV) to work. As the bus driver approached Lu and Duke near an intersection with a garage, the driver said he saw two men standing there waiting and waving to get onboard. He further said he seldom picks up passengers along the road at that hour in the morning, but he stopped and took them onboard. They had suitcases and looked like weary travelers.*

The bus driver immediately suspected Lu and Duke of something, he didn't know what, because they looked to him like they had spent the night along the railroad as their flesh and clothes were very dirty with coal dust. The driver later described one of the men as having a tear in the right leg of his trousers and that both men's clothes gave the appearance of having been in the weeds and bushes. He further described their shoes as being dusty and looking as though they had had a quick brushing with a cloth. Both Lu and Duke looked rough, but the driver had seen rough-looking customers and passengers before thinking they were probably coalminers wanting to take a trip right after they had gotten off work. But on second thought he could see they were wearing suits. [Lu and Duke were still wearing their snazzy suits that were almost unrecognizable due to how dirty and filthy they had become.]

The bandits had entered the bus and offered a five-dollar bill for fare. The driver told them that he had no change, thinking they might decide to hold him up if they saw he had a few dollars in his change-making and fare money box. Lu and Duke took seats near the front, and Duke rounded up a one-dollar bill for fare from his pocket and handed it to the driver. The driver took it and said that he'd settle any differences later. He told his new passengers to put their bags beside them. "We're not that crowded this morning and welcome aboard." The other two regular passengers, two men dressed in coveralls, were also sitting near the front of the bus. All were in conversation range of the driver.

All the way to Charles Town, the other passengers and the driver talked of the train robbery they had heard about overnight. They kept wondering aloud where the robbers were now. "There were at least four of them, that's what I heard. There could have been more to be able to stop that train to

rob her. I wonder how much money and stuff they got. They're probably somewhere in the mountains by now. Nobody will ever find them."

Lu and Duke did not attempt to engage the people around them in conversation, but when they were addressed, they talked about their car that had broken down about fifteen miles from Martinsburg and how they had hiked to get on a bus. When questioned, Lu said that he was on his way to Akron, Ohio, while Duke said he was on the way to Warren, Ohio. They were tired and just wanted to get home and arrange a wrecker for their car later.

During the travel conversations, and upon being asked other questions, Lu and Duke told conflicting stories of where they were from and about the "accident" they had been in. Duke was trying to blend in seamlessly, but Lu's cold stare was telling Duke to shut up and let him do the talking. Duke quickly caught on and kept his mouth shut from there on out. Lu smoothed out the questions and asked the others to please let him and Duke get a little rest, as they were very tired and worn out with the car wreck and all.

The bus arrived in Charles Town and parked. The driver said later that he had a notion to turn the men in but didn't. He did think that they were very suspicious of something, mainly because he hadn't ever seen them before and they looked grimy and beat up for so early in the day. He left them alone and went into the nearby snack shack at the bus stop during a twenty-minute layover to grab a bite of breakfast. His bus was being refueled, getting ready for the next leg of his route to the Mountain Mission rural community. By now, a massive manhunt for the train robber and tavern bandits was brewing. Lu and Duke went into the snack shack's washroom to clean themselves up a little bit.

From Charles Town, West Virginia, to the Mountain Mission community, only one other male had gotten on the bus, but from there into Leesburg the driver was alone with the robbers. The other three passengers had gotten off. The driver was trying to concentrate on his continual shifting of gears to accommodate the steeper grades they were encountering. He lit up a cigarette and offered one to Lu and Duke. They both nodded a no thanks. The driver later said that it was about the time he hit the higher mountains that he began to get a little scared. He said that if the men had attempted to hold up the bus, he didn't know what he would have done.

After a few miles, Lu spoke up and said to the driver, "We come from well-to-do families. Here's that five dollars we tried to give you earlier. Here, take it as a tip to let us get a little shuteye." The driver took the tip but kept a careful watch in his rearview mirror. The driver later said that they tried to sleep, but he saw they were unable to do so, as he kept glancing back at them.

He thought that they were legit and kept thinking that if they had wanted to try something, they would have done it by now. The driver was going back and forth in his inner thoughts about Lu and Duke, as he really couldn't decide for sure about them if they were good guys or bad guys. Maybe they were good guys just wearing dirty clothes.

Arriving at Hillsboro, Virginia, another stop along the route, for more possible passengers and a bathroom break for his current ones, the driver found a phone that was out of Lu and Duke's sight. To be on the safe side, he called ahead to get the sheriff at Leesburg, Virginia, to meet them at their next scheduled stopping place, reporting possible suspicious passengers. The bus ventured on.

As the transportation pulled into Leesburg, the sheriff (or any other possible help) was not to be found. The driver again left the bus and went to a snack bar as a break from driving. Soon the sheriff made his appearance, but the suspicious men were nowhere to be seen at first. In a short time, Lu and Duke went into this stop's snack bar. The sheriff looked them over but didn't say a word. As Lu and the sheriff met eye to eye, Lu knew that this guy was a coward who wanted no part of him and Duke. Lu had an innate sense that this guy couldn't pull his weapon and shoot anyone. Lu somehow surmised this in their brief eye-to-eye meeting. The head bandit would have probably drawn down on him if there had been any sign or indication of trouble. Maybe the officer didn't have backup, or maybe he was too scared. Regardless, a good scenario had panned out, with no one getting hurt. There was no serious confrontation.

Lu and Duke didn't have time to sit down in the little snack bar area, as a loudspeaker announced that the bus to Washington, D.C., was boarding. It was the original bus they were supposed to catch, the one they had earlier purchased tickets for. The sheriff later said that they seemed like nice boys. He did walk the suspicious fellows to the bus, the one they were boarding to D.C. Lu made sure that the officer walked with Duke in front of himself. Lu realized that the officer probably knew the deal and had decided to play it cool, especially with all the people milling about.

The bandits boarded the D.C. bus, and as a friendly gesture in cockiness, they waved goodbye to the officer through the bus window. They were really pressing their luck, as Lu was now sure that the copper would be wasting no time in spreading the alarm by phone and two-way radio. Lu hoped that an innocent wave would calm the sheriff into thinking that maybe he and Duke were not the train robbers. The bandits were now on a new bus with another driver. Onward to D.C.!

The sheriff falsely reported to the D.C. bus driver that he had questioned Lu and Duke and that he was satisfied that these were not the wanted men. However, he did tell the driver to keep an eye on them. Thinking that it was best to cover his tracks, the Leesburg's sheriff called the Martinsburg Police and said that he believed that he had probably permitted the guilty men to escape. It was at this time that the Washington Metropolitan Police were alerted to watch this bus, which was to arrive in D.C. at about 9:00 a.m.

By now, a massive manhunt of thousands had been formed. Law officials definitely thought that the bandits had hopped on another train from one of the sidetracks near the tavern they had robbed and from where the Ambassador train had been backed up. A human chain was combing the mountainside leading away from the robbed tavern. Thousands were searching for the train robbers.

The earlier bus driver later said that he received no reward of any type for making his hot-tip call to authorities and was kidded by fellow workers about his payoff to keep quiet. Lu and Duke had not paid him off. Afterward, the driver said that deep down, he thought they were probably the bad guys, but they caused him no trouble as he drove his route. But every time the robbery was mentioned among other passengers, the two fellows had a more suspicious look. The intensive massive manhunt was now definitely on!

There would be six thousand police, Federal Bureau of Investigation (FBI) and other law officials and agencies searching for Lu and Duke. Common folk volunteers also helped. The details and information that the law enforcement officials had to go on were very sketchy—a lot of hearsay and untruths. The law didn't have good information on the exact location of the bandits, either. They weren't sure that the bandits were the ones on the D.C. bus. Human chains were now combing the West Virginia mountains near the train stoppage and honky-tonk robbery. Side train track routes were being covered. Other trains were being searched for the notorious armed robbers. But where were they?

Posses of police from West Virginia, Virginia and Maryland were searching the Blue Ridge Mountains. A description soon came in: they were looking for two men about twenty-five years old, one with a mustache and the other wearing a sports jacket. That was the only description authorities had to go on.

Lu knew that sooner or later it could be a real mess of blood and gunplay when the police cornered them. He also knew that he and Duke would never give up. Lu thought that if the whole Japanese army couldn't kill him when he served in World War II, how could some hick mountain cops get him? They would not give up.

Never, never, never!

CHAPTER 9

Outdrawn by Police

They wanted to kill us, the same as they did with Dillinger.
—Luman Ramsdell

an, oh man, have we been cutting it close," Duke told Lu, who was sitting beside him in the bus to D.C. The bus was near capacity and full of innocent passengers. Its driver had been alerted to keep an eye on Lu and Duke. He never confronted them, as he just drove his bus. The driver was not armed.

Lu said to Duke, "Yea, but they'll be waiting for us at the D.C. terminal. They'll be shooting first and asking questions later, those damn coppers. They have no intention of capturing us. They just want to kill us, same as they did with Dillinger. They wanted him dead. They want us dead. That's how the FBI works for the headlines."

"But there'll be a lot of people around," a puzzled Duke inquired. "Bystanders will get hurt in the crossfire."

"They don't care as long as they get us. You got much ammo left for your .45? We ain't giving up," said Lu sternly.

"Just a full clip in the handle. None extra. We're not going to get out of this, are we?" asked a troubled Duke.

"I ain't got no extra ammo neither. My .38's got a few rounds left. When we take a couple of them out, we'll use their bodies as shields and—this is very important, now—we've got to get their guns to use. We're low on ammo. Remember your military training. Those coppers will not be

organized. We will. We'll blend in with the crowds. We'll get away. We've come this far. I still want to visit the president—don't you?" Lu asked of Duke, trying to calm him down from thinking about the highly probable imminent gunplay. The head bandit was thinking to himself that he and Duke wouldn't be taken alive.

"Yea, sure I do," said Duke. "Maybe he'll treat us right. We're World War II heroes, or at least you are. We're not going to harm him, are we?"

"Of course not. He's our commander-in-chief [referring to President Harry S. Truman]. I'm sure he's a nice guy," Lu said as chit-chat, trying to calm the despondent Duke. "We're on a roll. We've come this far. I want to meet the president. We will get to him."

"But we look too bad—our dirty clothes and all," pleaded Duke.

"OK, here's the plan. There'll be hundreds of coppers waiting on us at the D.C. bus terminal. We ain't going all the way there. Instead we'll get off a few blocks before it and find ourselves a clothing store," explained Lu.

"Sounds good. We'll do some shopping, eh?" asked Duke.

Lu had always prided himself on being immaculately dressed and in high fashion. He was the envy of all the hoods back in his hometown area of Youngstown because of the snappy clothes he continually wore in the style of a big shot.

While sitting in the bus as it moved along, Lu looked down at his muddy suede shoes and his torn and stained zoot suit slacks and was ashamed. He pondered to himself, *Think of it. Me looking like a hoodlum.* He looked up and out the bus window from his daydreaming and saw a clothing store across the street. They were in downtown D.C. now. The traffic was heavy. Lu could see people walking the sidewalks. There was a buzz of busybodies going to and fro.

Actually, the clothing store turned out to be a pawnshop with clothes in its street window. He pointed it out to Duke and said, "We're going to get dressed up for the president." Lu knew that they were probably going to die soon, and he wanted them to look their best. He never relayed that thought to Duke.

The head bandit reached up and pulled the stop cord. The bus soon pulled over at an intersection just blocks from the D.C. bus terminal and only five blocks from the White House. Lu and Duke got off with one suitcase in each hand. They walked across the street at a crowded intersection to get to the pawnshop, the S&W Pawnbrokers Exchange Co. on Pennsylvania Avenue. They entered the store and told the guy behind the counter, "We want the works! Clothes, underwear, socks, nice pants and new shirts. We'll be looking at your finer hats, too."

The clerk said, "Yes, sir. Let's start with the pants," as he pointed to stacks of pants he had on display. The clerk next started prying into their business with his conversation about where they were from, what happened to them to cause their rough appearance and where were they headed.

The pawnshop was full of goods, many odds and ends, and it had a little bit of everything. It was crowded with narrow aisles between the countless array of goods for sale. Most of the shop's displayed goods and trinkets were new and in very nice condition.

"We got some things, too, we want to pawn," Lu said as he started showing him some furs and jewelry from his suitcase. "We got another suitcase, too," he said as he pointed to the one Duke had with him. There was no cash in either of the suitcases, as Lu and Duke had taken it all out before they entered the shop. They had counted it on the bus—about $1,500.

"Okay, good. I'll take a look at it later," said the clerk as he took a cloth-measuring strip from around his neck. "Let me measure you for some pant sizes. Also, pick out some pairs you want. I'll tack them. My neighbor next door can alter and sew them to fit you. It won't take very long. And while he's doing that, I can look at your goods you want to pawn."

Lu and Duke permitted him to take some quick measurements.

An account of the pawnshop from newspaper articles noted:

> *The proprietor's son was behind the counter when Lu and Duke entered. "Right away," the son told reporters later, "I could see these guys meant trouble. They said they had turned their Buick over near Alexandria, VA."* [Alexandria is just south of Washington, D.C.]
>
> *Also in the shop were a couple of other customers of which one of them later told reporters, "Those guys meant trouble. They said they were on their way from Miami to New York. That story didn't impress me one bit. Their pants were all jagged. They didn't have enough scratches and bruises on themselves, not the kind you'd have if you had just rolled over your Buick, as they said."*

The first items Lu and Duke wanted to buy were some pants to replace their jagged ones. They also wanted to get cash for a few furs they still had, along with what they could get for their stolen watches, necklaces and rings. Remarkably, they still had some loot of value in their suitcases and pockets. The bandits also had about $1,500 cash on their persons.

Later in life, Lu surmised that one of the customers who was eavesdropping on their conversations about their car wreck must have become suspicious

and left the store to phone the police. It was easy to overhear anyone talking in the pawnshop as they were in very close quarters, with goods and customers right on top of one another in a very cramped space.

Police cars, without sirens blaring, were soon closing in on the area of the streets outside the shop. Two officers would be shortly entering the store. Lu later said that it was an absolute joke that one of the officers who entered the store to confront the bandits was acting on a hunch. That's what the officer later told the press.

"A hunch? Hell!" Lu told this writer. "With all the stores and shops up and down that busy avenue, one officer was trying to take the credit that a 'hunch' led him to that particular store where we were. What were the odds on that? I think not. That publicity-seeking idiot copper lied about his 'hunch.' He must have been trying to make the press think he was a super cop with some super mental powers. What an idiot! He also tried to murder me in cold blood when I was reaching for my wallet, not my gun. I hope he's rotting in hell." This author could tell that this part of the story was very disturbing to Lu, as he reminisced sixty years later. He did make it very clear that he never, ever wanted to shoot anyone—and definitely not a policeman.

It was about 10:00 a.m. on Thursday, March 10, 1949. The two police officers who entered the pawnshop were named Lomax and Kennedy. Lu would later in life call them "Liar" and "Coward" when reflecting back on the tragic confrontation in 1949 regarding his and Duke's capture. Both officers were privates in the Metropolitan Police Department, with Kennedy being described as the scout car partner of Lomax, who would soon fire the shot trying to kill Lu.

In the official report, the two officers stated that the pair answered the descriptions given for the train robbers and that they approached them to ask for identification. This sounds like a parroted statement from a police training manual. This author believes that if they thought they were on the notorious train robbers, they would have had their guns drawn while yelling and instructing Lu and Duke to give up. It's reasonable to think that they'd have checked to see if the suspects had identification on them *after* they were arrested and in handcuffs. Instead, the police just wanted to shoot first and sort it out later.

The account from newspaper articles noted:

> *The youthful gunmen slipped through roadblocks thrown around West Virginia roads Wednesday night* [March 9, 1949] *and early this morning* [Thursday, March 10, 1049] *came to the capital on a Greyhound bus.*

They were captured and one was shot within 5 blocks of the White House. Apparently the men attempted to pawn some of the loot in the pawnshop when Police Officer Elmer G. Lomax arrived. Ramsdell went for his gun and Lomax fired. Ramsdell was hit just below the heart. Ashton cowered back and gave up. Ramsdell was taken to Gallagher Hospital and not expected to live. The desperadoes were tracked down through a series of tips, the most important was supplied by an unidentified driver for the Emory bus lines [later uncovered—the driver's name was Billy J. Lopp].

But it didn't go down that way; the press and police had their own version. What really happened was that the officers asked for some form of identification for Lu and Duke while all four were very close to one another in the pawnshop. Quick-thinking Lu knew that he still had the train engineer's wallet that he had lifted from him on the train. He'd show it. It worked once before in fooling a copper. Maybe it'd work again. (Lu's real wallet was later found scattered on the floor of the honky-tonk tavern. That helped authorities during the manhunt to know who to be looking for.)

Officer Lomax ("Coward," as Lu described him) said that Ramsdell made a gesture toward his hip pocket as if to produce a wallet. The other officer, Kennedy ("Liar," as Lu described him), panicked and thought Lu was going for a weapon, not a wallet. Officer Kennedy, who was standing by his police partner, grabbed and shoved Duke into Lu. Then Kennedy yelled out to Lomax, "Let him have it, Woody!"

Lu, fearing for his life and in self-defense, reached back for his .38 in the small of his back. He believed that those officers were trying to kill him and Duke. Lu got his pistol out and was bringing it around his stomach to try to get a shot off. A shot did ring out from an already cocked service revolver, but it wasn't from Lu's gun.

Lomax had reached over Duke's shoulder and fired one shot at point-blank range into Lu. The policeman's .38 slug struck Lu's trigger finger that was grasping his own .38 while he was trying to bring it around his body to fire. That happened a split second before the policeman's bullet entered Lu's left side.

Lu felt his finger go numb as he fell to the floor. He did not lose consciousness, as he saw a big red bloodstain coming through his shirt in the middle of his chest. He thought for sure the copper would fire again to finish him off. He did not. No further shots were fired. Lu said that he could remember from his grogginess seeing Duke throwing up his hands saying, "I give up. Don't shoot!" Lu also said he vividly remembered

TRAIN ROBBER CAPTURED Young Train Robber Wounded As He Reached for Gun

Courtesy of the Des Moines Tribune.

the cop smirking over him. One total shot was all that rang out in the pawnshop—the one from the policeman.

This writer asked Lu if any of this was brought up in any of his trials, meaning his self-defense in the pawnshop. Lu replied, "Not a damn word. They were too busy praising officers 'Liar' and 'Coward,' yet they both admitted they had asked us for identification *first*. That's what I was reaching for before reaching for my .38. I was doing *exactly* what the police asked: trying to present ID. That officer wanted to kill me. It was obvious. I'll let history decide."

The one shot into Lu hit his trigger finger first before entering his chest from the left side only two inches below his heart. Lu never lost consciousness as his body fell to the floor of the pawnshop. The officers took a loaded .45-caliber army automatic pistol from Duke and asked both of the men directly, "Did you help rob the train in West Virginia last night?" Authorities still thought that Lu and Duke were only one part of a larger gang of men that robbed the train. Press reports had it at four train robbers, with descriptions from eyewitness accounts of the Ambassador train passengers.

"Yes was the answer from the bandits in both cases," the officers said. That part was an outright boldfaced lie according to Lu, who said neither he nor Duke ever said anything to incriminate themselves. (Duke would later confess fully to the press.) Lu said that he could remember vividly that as he was lying on the pawnshop floor after being shot, he had to endure the additional anguish of the smirking cop looking down at him. He felt sure the cop would finish him off, but he didn't.

Duke was whisked away and taken downtown to the Metro Police precinct. No first aid of any kind was rendered to Lu while he was waiting the excruciating minutes for the ambulance to arrive. Lu ultimately was loaded onto a rolling stretcher of an ambulance that arrived within about ten minutes of the shooting. Lu never lost consciousness the entire time and cracked jokes with the attendant while riding in the back of the ambulance.

A physician at Gallagher Hospital, where Lu was transported for treatment, said that a .38-caliber bullet entered Ramsdell's left side at the tenth rib and came out on the right at the twelfth rib. The doctor also said that the bullet missed the heart by about two inches and listed the man's condition as critical.

Lu later found out that the doctor had extensive experience in treating gunshots wounds from being in the battlefields of World War II. That doctor

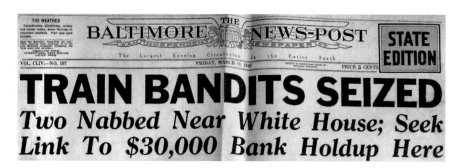

Courtesy of the Baltimore News-Post.

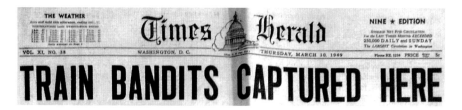

Courtesy of the Times Herald.

knew exactly how to treat and care for Lu. If it had have been any other doctor without that experience, Lu might have died as a twenty-three-year-old in 1949.

Headlines across the country read, "Train Robber Reported Near Death." A wire service noted, "Washington—Ramsdell, one of the 2 men who held up a crack passenger train on a spur-of-the-moment impulse and then tried to shoot it out with police when facing arrest was reported near death today. The FBI has filed train robbery charges against both men. Ashton, who was Ramsdell's accomplice, is being held under $50,000.00 bond. When arrested after a intensive 3-state manhunt the men had on them $563.82 in cash and change."

From Lu's account, he and Duke had about $1,500 in cash on them when they first entered the pawnshop. (They had counted it on the bus.) What happened to the other $1,000 or so? Who took it? Perhaps "Liar" and "Coward"? Or the pawnshop clerk? Or another customer? No one knows for sure. Fifteen hours after it started on the train, the bedlam was now over.

Lu told this writer, "Something you never forget, a priest hovering over you giving you last rites." That happened in Lu's room at Gallagher Hospital.

I asked Lu, "Did you repent?"

"Nah, not really. Well, I probably did after the priest kept prodding me."

From newspaper articles on Saturday, March 12, 1949 (a few days after the robbery of Wednesday, March 9), came this account:

The youth [Luman Ramsdell] who was shot by a policeman after holding up a train Wednesday was given a good chance of living last night. He and his companion were arrested in a pawnbroker's exchange at Pennsylvania Avenue near the White House after they staged a Wild West style train robbery near Martinsburg, WV. The wounded man, 23, was still in critical condition at Gallagher Hospital. But doctors said a 90-minute operation to repair injuries to his stomach and liver improved his chances of living. The bullet penetrated his stomach, ripped through his liver and came out his back just opposite the space between his eleventh and twelfth ribs. The bullet missed his heart by only 2 inches. Some infection has set in, but it was minimized because Ramsdell ate little the day he was shot. Considerable stomach contents spilling into the abdominal cavity would have increased infection. Meanwhile, Ramsdell's crime partner, George L. Ashton, is being held under $50,000 bond on train robbery charges by the FBI.

Additional newspaper accounts after the capture of Lu and Duke noted the following:

Both men, former convicts from Youngstown, OH have admitted they yanked the Baltimore & Ohio crack Ambassador Express to a stop, robbed passengers and crewmen at gunpoint, and later held up a nearby tavern. Both zoot-suited youths are products of broken homes who got into scrapes during military service.

As a teenager Ramsdell was sent to the Ohio state Reformatory three times after brushes with police involving auto thefts and armed robberies of grocery stores. He was pronounced a "constitutional psychopath" by doctors at the Youngstown Receiving Hospital. Ashton, as nicknamed "Duke," was a poor youth, reared by an uncle in a rooming house. He too had done time in the State reformatory.

At the time of the train robbery Ramsdell was married to an attractive blonde and maintained an expensive modernistic apartment and drove the latest model convertible car.

A few days after Lu and Duke were captured in Washington, D.C., after pulling off the train robbery, police in Coral Gables, Florida, held two female companions of Ramsdell and Ashton for questioning: Jeanne Johnson of

THE EVENING SUN 5★STAR

2 SEIZED IN TRAIN HOLDUP
CONFESS, D. C. POLICE SAY

Courtesy of the Evening Sun.

Portland, Ohio, and Jeanne Dupuy of Newport Village, Ohio. Police reports noted that they had stayed in an adjoining room occupied by the bandits prior to the train robbery. Johnson told police that none of the four had any money on them, but the two men soon had "lots of money" after a local grocery store was robbed of $732 in cash and a ring valued at $1,000.

Lu informed this writer, "Those crazy broads, trying to pin that Coral Gables robbery on me and Duke. Hell, those two bitches had to have robbed a Florida grocery store on their own. Duke and I weren't even in town then. Crazy broads."

Relatives related to the press, "Lu was just a wild kid, that's all. Thought he [Lu] was better than everyone else. Duke's mother said Duke had a tough life since he was three months old."

The question of where Luman C. Ramsdell and George L. Ashton, two men being held in Washington, D.C., for train robbery, would be tried remained in doubt between federal and state courts. A U.S. northern district attorney sought to bring the two men to trial in federal court in Fairmont, West Virginia. Meanwhile, state warrants were issued in Martinsburg, West Virginia, in an attempt to bring them before a grand jury of Berkeley County Circuit court. The justice of the peace charged Ramsdell and Ashton with armed robbery and felonious assault. If taken into federal courts, the two men would face maximum sentences of ten years and fines of $5,000 each. If tried in state courts and found guilty of armed robbery, they could be given maximum sentences of life imprisonment or possibly the death penalty.

Duke was quoted in the press as saying, "I know I am guilty of the charge. There is no need for a preliminary hearing." Under arraignment before a United States commissioner, he was ordered held under $50,000 bond.

A newspaper headline on Monday, March 14, 1949, read, "Court Tells Bandit to Get Attorney, Plead":

Washington, DC—George L. Ashton, 21, who was captured here Thursday, March 10, 1949 after a brief gun fight in which his holdup partner was wounded, told the Federal district court he wanted to plead guilty. The judge

Courtesy of the Morning Herald.

interrupted to ask the youth if he had a lawyer. Ashton said he had not been able to get one, and the judge instructed him not to discuss the case or enter a plea until he had talked with a lawyer. The judge said he would appoint a defense attorney if Ashton was unable to get one. Ashton told the court he wanted to be tried here for the robbery. The district attorney's office said it had not decided to prosecute him on a charge of theft from interstate commerce, which carries a maximum sentence of 10 years imprisonment, or to pursue prosecution under an anti-racketeering statue, which provides a maximum penalty of 20 years.

Another article reported on Lu's wife:

Mrs. Luman Ramsdell, wife of the confessed B&O train robber, admonished photographers who made her picture and ducked her head after getting in a maroon convertible. She and her mother-in-law visited Ramsdell at Gallagher Hospital on Saturday, March 12, 1949.

The two visited with the wounded man for 30 minutes and tried unsuccessfully to have him transferred to another hospital or from the detention ward to a private room at Gallagher. Ramsdell and five other patients occupied the same room.

Hospital attendants said the wife, Mrs. Lillian Ramsdell, polo-coated and wearing sunglasses, appeared "sore" and "unfriendly" because police shot her black-haired husband as he was presenting identification in the spectacular capture Thursday morning in a Pennsylvania Avenue pawnbroker's exchange. She later scolded reporters as "scandalmongers" when they asked for comment on her husband's dilemma.

Attendants said he was in "very good condition" although still on the critical list. The mastermind bandit was cheerful and comfortable, as he smoked and chatted with his wife and mother.

Lu did not remember his wife and mother visiting him in the hospital. He was too heavily sedated. The head bandit had survived after being shot two inches below his heart.

Shoot first and ask questions later!

CHAPTER 10

Happy Trails

You learn a lot of crooked things when you hang around crooked people.
—Luman Ramsdell

While still in the Gallagher hospital, and one week after the doctors had put a fifteen-inch stint in his stomach to sew up his innards, Lu was told that he had to appear in court for a preliminary hearing. Lu said, "Fine, but where are my clothes? No clothes, no go." The clothes were not provided, so Lu would not cooperate, as he had earlier requested clothes from home. Four deputies brought handcuffs and chains to Lu's hospital room with the determination to take him to court. Lu braced himself as he stood on the corner of his bed. He was ready to fight the deputies even in bedridden condition. Lu was still very weak from being shot and operated on a week earlier.

The cops were about ready to just pounce on Lu when the doctor came in and asked what was going on. The officers responded, "We're taking this thug to court."

Lu said, "No, they're not!"

The doctor defended, "No, you're not going to touch my patient." The doctor saved Lu from going to court that day. Within a few days, Lu's clothes came in from Youngstown, and he peacefully went to his preliminary hearing in D.C., his first court appearance since the train robbery.

Lu was quickly able to obtain a magnificent attorney by the name of Marie Leachman of Atlanta, Georgia. Her upfront fee for handling this high-profile and headline-making case was a staggering $10,000, an

exorbitant amount of money in 1949 and comparable to $100,000 today. Lu was able to raise that amount by borrowing against a personal trust fund left to him by his deceased father when Lu was only two years old. Lu's criminal connections (mainly his kingpin friend) also assisted behind the scenes with his defense aid and had recommended Leachman. Money was no object when it came to Lu being able to obtain the best possible defense of any available from anywhere in the country.

During the legal proceedings leading up to Lu's federal trial, to be conducted in West Virginia, Leachman miraculously worked out some bargaining magic. Three states desired Lu on charges, including Ohio (a twenty-year sentence for violating parole from earlier youthful offenses), Florida (horserace fixing, of which the indictment was ultimately dropped on clerical errors) and West Virginia (150 armed robbery charges, tavern robbing and stealing cars). The attorney cleverly arranged it so only the federal boys would have Lu—the states would not. The states would have joint parole with the federal court. Lu went to federal court a few weeks after the train robbery, and from that court trial, he was found guilty and sentenced to twenty years at the Atlanta Federal Penitentiary. But there was hope. He had a chance of possible parole after one-third of his time had been served.

Lu's attorney regularly visited him in the pen at Atlanta. She liked Lu and lived in the nearby Atlanta area. He ultimately did serve just one-third of his sentence. He spent six years and eight months behind bars before being released on parole. That's all the actual time he did for his cavalcade of crimes.

Although Lu and Duke were tried separately and had different legal counsel, Lu thought that his and Duke's actual serving times behind bars were about the same—approximately seven years, all for stopping and robbing a moving train while terrorizing 150 people, not to mention the tavern robbery and stealing getaway cars. The lawyer had pulled every string! The three states couldn't touch Lu, as the states had a joint parole arrangement with the federal court.

Soon Lu and Duke would be having their last contact together for quite a while (more than sixty years), as they rode to Atlanta from West Virginia in the same police van. Lu said that the three transport officers were very nice and respectful. The officers took the handcuffs off both Lu and Duke when they went into restaurants to eat during the trip.

Lu and Duke caused no trouble in any of the restaurants or on their continuation trip to Atlanta. After arriving in Atlanta, they both went to

Receiving and Evaluation (R&E) lockup for thirty days. Lu and Duke would see each other only one time in the yard of the Atlanta pen, as Duke was soon green-bagged and transported to the federal penitentiary in Lewisburg, Pennsylvania (when an inmate is transferred from one facility to another, all his belongings are packed into a large green bag). Lu also told this writer that Duke made good friends with a top-ranking mafia man while housed there. That man continued to help Duke after he was released.

The train robbing bandits would never communicate with each other again until a phone call arranged between them some sixty years later by this writer. With press contacts and others, we located Duke as a ballroom dance instructor in Hawaii. He was doing fine, was somewhat remorseful but not as much as Lu and had put his train robbery past behind him, even though some of his family members had not ever forgiven him. I think after Hawaii, Duke moved to Florida.

Lu informed me from their phone conversation that Duke was paroled at about the same time as himself, but a few years later, he hit his parole officer in the face. For that, Duke was put back into prison for about three years in Leavenworth, Kansas. Lu said that Duke was still mad and disgusted about the police trying to kill them in the Washington, D.C. pawnshop. Duke told Lu, "They didn't have to shoot you!" The head bandit agreed and realized that Duke was not as mellow as he had become later in life.

In 1957, when almost seven years had passed from the time Lu was first incarcerated, some great news came from his parole board. He was getting out! Lu became one of the first ever to be paroled in the history of the federal parole board hearings that had a detainer for continued detention.

Lu didn't have just one detainer—he had three. This meant that three states wanted him regarding his continued imprisonment after the feds were finished with him. Another amazing aspect about his parole is that the board had never listened to someone with a detainer. Lu informed this writer that states will try you and come and get you after your federal time. If an inmate had a detainer, the parole board would not even listen or talk to him or her. But Lu's scenario was an incredible exception. How? Money, connections and a determined attorney. After a while, Lu's connections would include the warden, assistant warden and prison supervisors. All became very influential people who vouched for Lu. And he had won them over to his side. Most notably was James V. Bennett (1894–1978), who was a leading penal reformer and prison administrator. He befriended Lu and helped him in grand ways. Lu was a national celebrity prisoner and drew his attention. Lu compared Bennett's power and influence to that of J. Edgar Hoover.

After almost seven years of being incarcerated in the Atlanta Federal Penitentiary, Lu was a changed man. During that time, he was a celebrity kingpin, in fellow prisoner lingo, as he was "the walk and the talk." He had been national headlines. He was a train robber, a crime simply unheard of since the Wild West days. Lu made friends with another mafia kingpin while there. Lu also said that while he was never involved, he knew about a "snitch" or "rat" who was done in and killed for his actions. The method was simple: While the snitch was confined in a cell, gasoline would be thrown on him. A match would be struck. The snitch couldn't get out and would suffer a horrible and painful death.

In the hierarchy of the society of inmates, Lu was at the top as a notorious train robber. He was respected even above the bank robbers who were also serving in the same institution. Lu was always served good food. Many times, he was eating steaks, while others were eating mystery meat and low-quality hot dogs. Admiration came from almost all the inmates and even some of the prison guards. The notorious train robber would soon have to win over the warden. He had to. He did not want to go to Alcatraz, and that possibility was brewing.

One day, the warden, who was tired of Lu getting preferential "big shot" treatment from other inmates and some of his own guards, wanted him out of his facility. The warden called Lu into his office and said, "Change your ways of ruining my prison or go to Alcatraz! I'm starting the paperwork. You need a miracle to happen within a couple weeks. We're shipping you to Alcatraz on the West Coast. You're out of here. You've got two weeks for your miracle. Two weeks to impress me, that's all."

Lu didn't think he'd ever leave jail, whether from the Atlanta pen or from the three states that still wanted him and now, possibly, Alcatraz. He realized that he'd probably be a "lifer," as he had been threatened with the strong possibly of being sent to Alcatraz, known for its hard-time lifelong sentences. But the criminal mastermind's wheels started to turn and churn. How could he possibly "escape" Alcatraz (or rather, not go there)? He feared that if he were sent there, he'd automatically become a "lifer."

It was pretty harsh words and plan of action by the warden, as Lu had been doing fine as an inmate and top dog at the Atlanta penitentiary. Lu was allowed to go to the Atlanta prison library to look to see what he could possibly do to change his life. With the threat of "The Rock" (Alcatraz's nickname) looming over him, his quest was to stumble on something or anything that could keep him where he was. He knew that it was a long shot at best, but he had to try to come up with a plan.

Alcatraz, "The Rock," San Francisco, California. *Courtesy of the author.*

At the library, he came across a magazine article by Erle Stanley Gardner (1889–1970). The article's writer was a lawyer and famous author of detective stories, best known for the Perry Mason series. In the article, Gardner was asked, "What would you do if you were in jail for life? How would you get out or what would you do?" He replied, "I would do something so good, I would learn something so well that people would look at me in the future and say what is that man doing in jail?"

That statement had a profound influence on Lu's life. He responded to this writer in a taped interview about this: "And that was my philosophy. I mean, I didn't think of it constantly, but it never left my mind. That was the way, as they told me I would be in jail for life. I read that, see. There'd be no way I'd ever get out of jail. And I don't think I just purposely said, 'Well, I'm going to learn something so good.' I don't think that happened. But that's what happened though really. Actually, I did learn something so good because I had all the time in the day and night to learn something."

Lu took up the hobby of portrait painting. It changed his life. He became very good at painting. He was able to prove that to the warden. He "escaped" Alcatraz, as the warden decided to keep him in Atlanta. Lu was becoming a better man. He had found a tremendous hidden talent for portrait painting. He impressed the warden with a really good portrait of the warden himself. That softened the warden's bitter feelings toward Lu, as the hardened career criminal was changing his life for the better.

The notorious train robber spent his time in the Atlanta pen, and nowhere else, before his parole chance. Lu had worked his way back into

the warden's favor to the point that the warden wanted to help Lu. A prison guard by the name of John Boone had also befriended Lu since day one of his incarceration. (Boone was one of the first black federal prison guards in the country.) That same guard rose up through the ranks to become a warden and helped with nationwide prison reform. Lu said that Boone's brother was a preacher who later got to marry him a few times. (Lu was married five times throughout his life.)

As a model prisoner, Lu was awarded a certificate of participation, as he consented to malaria trials in which he was injected with test drugs to combat the disease transmitted mainly by mosquitoes. Lu always had respect from other inmates and earned that same respect from the warden and prison guards. He was the notorious train robber who had calmed his ways. Lu repeatedly said that he never wanted to hurt anyone, only to intimidate them during his criminal escapades. But he did say that he always had to try to defend himself if the situation warranted.

After Lu's release, with his parole approval, in 1957, he reentered society. The stipulation was that he could be taken "out" or stay "in" prison. He chose to be "out," with strict instructions to report to a parole officer once

Lu is paroled!
Courtesy of the author.

a month. (Some prisoners choose to stay "in" during their parole periods to greatly lessen their chance of screw-ups that would put them back in for their full original sentencing.) Lu did not want to return to his roots and hometown area of Youngstown, Ohio. So, why not see what Atlanta had to offer? He stayed in the Atlanta area until his move to Spartanburg, South Carolina, to expand a video poker machine business that he and his "friends" had started. He remained in Spartanburg for the last few years of his life.

He applied for a job as an advertising consultant in the Atlanta area and did quite well designing advertising campaigns. Lu said that it was amazing— when he applied for the job as a thirty-year-old, they never asked him about his background, if he was a convicted felon and so on. He said his credit was perfect. He didn't owe anyone or have any debts. From his new job, he applied for a Veterans Administration loan, bought some land and built a house. As an ex-marine with excellent credit, he was quickly fitting right in with society again. (He also told this writer that there's no such thing as an ex-marine; you're a marine for life.) Lu also became active in the nightclub and bar business and became friends with Johnny Esposito, who was known as "Mr. Nightclub" around the town of Atlanta. Lu developed and nurtured his relationship in the nightclub business, as Johnny's Hideaway, a very prominent club, was one of his advertising campaign accounts.

Rising up in the ranks, Lu became one of Esposito's trusted men in the club scene. Lu's entrepreneurial spirit would soon blossom, and he said that Esposito noted that there were two words one should know regarding how to become successful in the nightclub business: "Luman Ramsdell."

In one instance, Lu was asked by his bosses in the nightclub business to book a certain entertainer for their club. Lu called up the booking agency. They said the entertainer's price was $1,700 for three nights. Lu thought that was too high, so he passed. After a few days, it was decided to go ahead and book the entertainer. Lu called the agency back and said they'd take him at $1,700. The agency said the price was now $2,700. Lu scoffed at that and hung up the phone. Another day passed, and the club decided that they'd pay the $2,700. So Lu had to eat crow and call the agency back again. This time they said the price was $3,700. Lu said, "No way," and hung up the phone again. The club did not end up booking the entertainer, James Brown.

Lu said that it was routine for him to drive around various celebrities who had been booked with the clubs he was associated with, including a topless club. He remembers chauffeuring around comedian Pat Paulsen. Lu said that he was a nice, funny man who also, as a joke, ran for president of the United States in several elections.

One time, they had booked a band to perform at their topless club. The band didn't realize the topless aspect until it arrived in Atlanta. Then the band refused to perform. Lu spoke to its manager and said, "Look, I've just gotten out of jail, and me and my friends are paying you and your group well to perform." The group did perform. Lu couldn't remember the name of the group but thought it had "Railroad" in its name. This writer presumes it was probably Grand Funk Railroad.

Lu said that they had a continual string of performers coming to their nightspots. He said he met Frank Sinatra Jr. and numerous others. Lu learned the business and soon was part owner of two to three clubs in the Atlanta area. One such club would house one thousand patrons on Saturday nights, charging $0.50 admission at the door. He said another was even larger, as they could take in as much as $1,000 to $5,000 in cover charges on any given night, especially when big-name entertainers were performing.

Lu's marketing and advertising skills were really paying off. His nightclub connections were fruitful. Lu now had plenty of money. At times, his tactics and shenanigans were borderline shady but mostly legal and within the framework of the law.

Even though he was married, Lu loved fast cars and fast women. One day, when he was at a new car dealership in the Atlanta area, a few undercover detectives who knew exactly who he was were also in the dealership browsing around. They didn't harass Lu, but they certainly knew of his criminal past and current associations on the nightclub scene. Lu bought a new car while there. It was loaded with all the latest accessories. He paid for it in full with cash. He drove off and went merrily along his way.

Afterward the detectives approached the salesman who had just sold Lu his new car. "Do you know who that was?"

The salesman, who could easily spot the undercover detectives, replied, "Yes, an excellent customer."

"He's nothing but a lowlife thug," rebutted one of the detectives.

"Maybe so, but I seriously doubt if you two hocked everything you could ever pay cash for a new car. You'll never make the same kind of money Ramsdell makes." The detectives left the dealership without uttering another word. The salesman later told Lu the story.

A few weeks after obtaining his new car, Lu had been out drinking and was speeding. He was still on parole. A police car started chasing him. Lu sped up but soon stopped. As the two officers, who had exited their police vehicle, started approaching Lu's car on both sides, Lu pressed the automatic lock button to lock all his car's doors. The officers tried to

open Lu's doors from each side. They couldn't. Lu laughed at them and drove off.

The police radioed for help. Lu could remember swirling around in traffic so fast that he slid over to the passenger side across his slick leather seats. He was reaching over trying to steer with his left hand. A roadblock was soon set up on the street Lu was driving on. When Lu got near it, he ditched his vehicle and started running on foot. Without hesitation, the police started firing their weapons at Lu. One bullet struck the back of Lu's right leg. He had been shot by the police, again. Lu was quickly arrested. His injury was attended to and was not life threatening.

This writer asked Lu, "You were in big, big trouble now, correct? Meaning your being on parole and all."

He replied, "Nah, I hadn't been doing nothing but speeding. The police were in more trouble than me. My first phone call was to James V. Bennett, my friend who happened to be the director of the Federal Bureau of Prisons. Next I called Marie Leachman, my female lawyer."

"How did your lawyer handle it?" I questioned Lu.

"It was really a 'wash' with me being on parole and the police shooting someone for speeding and on foot." This writer shook his head in amazement upon hearing Lu tell it. Unbelievable but true—another case of Lu's good luck.

At times, Lu's bar businesses, the ones that he was associated with, served underage drinkers. That was a big market. He remembered one time when the police were waiting outside their doors one night checking IDs. They were checking the ages of patrons, but not inside and not as they entered—only as they were leaving. So, at closing time, the bar management announced to their patrons that the police were outside and that all were welcome to spend the night there and inside. Lu said that he remembered seeing girls everywhere sacked out, including in their private office. When the patrons left the following morning, they had sobered up and told the waiting officers that they had only been drinking cokes. There was no law against a business if it wanted to let friends spend the night in sleepovers.

As a very creative person, Lu conceived and designed nightlife coupon books. The bars he was associated with sold them successfully for one or two dollars apiece. Lu did all the artwork and came up with the adverting gimmicks:

- Unescorted ladies drink free from 10:00 p.m. to 11:00 p.m.
- Buy two liquor drinks, get two free.

- Free popcorn with all draft beer purchases.
- Bring a new friend and get a free appetizer.
- No cover with coupon.

Lu was quite a whiz for generating publicity. He was also instrumental in his idea of a lighted dance floor that led to the concept of discotheques. In one of his topless bars, Bikini-a-Go-Go, he installed a trampoline and a trapeze swing bar for the beautiful women. He was nothing short of an enterprising genius at attracting crowds to his bar scenes. Many of his highly successful ideas were later copied—or, as Lu put it, "stolen"—by others.

There was a meat processing plant in the Atlanta area. Lu and his associates posed to its owners a business proposition to purchase their scraps and discarded meat byproducts. The plant had been paying someone to haul them off and, on occasion, was able to sell some of them to dog food companies. Lu would solve their problem entirely. He'd take it all, haul it off and pay them more than they were currently getting—a win-win scenario for all. Lu wanted all of those worthless scrap pieces and byproducts, and the plant was happy to take him up on his offer.

With the help of his business "friends," they would repackage the scraps and add special flavoring and spices. They produced this big-dollar gourmet meat in special filets that they sold to upscale Atlanta-area restaurants. The end product was exorbitantly priced and only afforded by the higher class and big spenders at finer restaurants. But they had no idea what they were eating.

With his business partner, whom Lu referred to as "J.T.," he went on to found his own advertising agency. They also opened up an eatery known for good sandwiches and their special-tasting spaghetti sauce on Peachtree Street in downtown Atlanta. They also owned and started up a few bars. One time, J.T. wrote a screenplay in spite of the fact he couldn't read nor write. Lu laughed about that and said he dictated it to someone. Lu and J.T. were quite the savvy business entrepreneurs. They certainly knew how to generate cash.

Lu never forgot his talents as a painter. He said a friend of "Mr. Nightclub" Johnny Esposito was founding a new upscale magazine called *Platinum* geared toward millionaires, with Rolls-Royce as one of its advertisers. As a favor to Lu, there was a nice article on his paintings in the premiere issue:

> *Some painters go for centuries before being discovered. Luman C. Ramsdell's first major public display will be at an art reception along*

with the premiere issue of this magazine in Colony Square Gallery. Readers of this article will have the grand opportunity to experience a firsthand review of 38 paintings. It is our humble opinion that the works ranging in price from $500 to $4000 will significantly increase in value over a short time. At a previous Piedmont Art festival, Ramsdell's paintings outsold all others. Since this, and until now his paintings had not been on display and for sale. Let us expose you to the Art-Hate-Hope exhibitions of "The RAM" who was born April 1, 1926—One damn, long, hard, bitter loving apprenticeship 30 years before the dawn. Now a vastly mature artist, The RAM's slashing Germanic painting style seems non duplicable. Pools of swirling color can be seen in minute detail. His favorite medium is buckets of high gloss enamel that dries in less than 20 minutes. A textbook could be written about his artistic styles and unique mannerisms. He achieved victories over the elements that were battling him although sometimes the paintings won and he had to destroy the obnoxious monsters he had fathered. Ramsdell produces the injured as sane in his highly emotionally charged works and style. A frustration to change the world that Mr. Ramsdell did not seem to control.

Maybe that sums up the life of the train robber himself.

Epilogue

I had never ever heard of Spartanburg, South Carolina,
until I saw it on an exit sign off I-85.
—Luman Ramsdell

S ometime during the late 1990s or early 2000s, Lu moved from Atlanta and settled in Spartanburg, South Carolina, to expand a video poker business that had saturated the Atlanta area. His "bosses" had heard about the intersection of two interstates, I-85 and I-26. Lu drove from Atlanta along I-85 looking for a Spartanburg exit. He had never heard of Spartanburg, about an hour southwest of Charlotte, North Carolina.

He took a Spartanburg exit off the interstate and soon settled in and remained under the radar the last several years of his life. Video poker machines became illegal to operate in the state of South Carolina, so Lu quit the business and retired. He became active in a local stamp collecting club and loved to sit on his house's porch watching squirrels work and play. He would hang out in the mornings at a nearby Hardee's. I'd meet him there for conversations about his life's story. At times, we'd switch it up and meet across the street at Bojangle's in the Hillcrest area of Spartanburg. The former bank robber was well known in those restaurants—not as a former criminal, but just as Lu, a nice guy. Most everyone spoke to him. He was well liked.

Lu would get out at night to attend many of this writer's trivia gigs. Most notable was at Basil's, a locally owned eatery. Lu became a regular

Point-blank questions answered. *Photo by S. Deane Brown.*

of the trivia night groupies. The trivia competition was tough going, but Lu held his own and was trivia champion by winning a round or two on numerous occasions.

This writer was shown a sampling of Lu's portraits and paintings at his home during one of our many conversations. I remember the massive size of the portraits, some four by six feet and some larger. They were dark and macabre—one of Mussolini, one of Hitler and one of Armageddon. He wanted to give me a few, but I couldn't accept. They were his prized possessions.

At eighty-six years of age, he still drove himself around wherever he wanted to go up until about four or five months before his death. In May 2012, he was at lunch sitting in a restaurant's bar area not too far from his home. He passed out and fell in the floor. Lu had suffered a stroke. Although he recovered somewhat, his speech was never the same. He was placed in a nursing home called Camp Care in Inman, South Carolina (about ten miles north of Spartanburg, South Carolina). I visited him there. His eyes lit up in recognition. Near the very end, he was transferred and passed away

under loving care in a hospice house in Spartanburg. No one who kindly and graciously attended to him in his final days knew of his notorious past. Lu died peacefully in his sleep.

About a year before Lu's stroke, during one of our many interviews and talks, I asked him how he'd want his obituary to read. He quickly replied:

Ex-Marine
Ex–Train Robber
Ex-Convict
Ex–Advertising Developer
Ex–Nightclub Entrepreneur
Ex–Bad Guy
Ex-traordinary Artist

Instead, a one-sentence obituary quietly marked the death of eighty-six-year-old Spartanburg resident Luman C. "Lu" Ramsdell on September 23, 2012, according to the *Spartanburg* (SC) *Herald-Journal*.

Although Lu was a real-life reformed thug and bandit who lived an incredible life, he was always very nice and friendly to me. At times, I still wonder about things and am not sure about them to this day: Were the cash and loot that he and Duke buried near the water tower and big tree just off the tracks somewhere outside Martinsburg, West Virginia, in 1949 ever discovered? Will his many portraits and paintings someday turn up in some gallery or show being prized and priced at untold sums of money? Are there sacks of cash or money buried in the yard or hidden in the walls of his last place of residence on Beverly Road in Spartanburg, South Carolina?

I do know something, though…

Lu and Duke were America's last moving train robbers!

Point-Blank Questions

I engaged in personal interviews with the head bandit himself between 2009 and 2012, right up until his death.

Your name is Luman, yet you go by "Lu" or "Lou"?
Lu is short and my preferred way, but when I write it out, I usually write it as "Lou." Lu is my correct way, but it really doesn't matter.

Why did you decide to stop and rob a moving train?
We were drunk [referring to himself and Duke], *and the bartender didn't think we had money to pay our tab. Things escalated after that.*

Your Tommy gun didn't work. Why did you keep lugging it around?
I hoped to get it fixed.

I would think when the porter on the train saw it fall out of your suitcase, that aroused wild suspicions?
That did make his eyes widen. Probably a good thing it wasn't working 'cause we could have easily hurt a whole car of people in our drunken state. They were all sitting ducks. I'm a robber, not a murderer.

How many people do you think you swatted with the butt of your pistol when the train robbery was going down? And did you think about just shooting some of them?

I didn't want to shoot anybody. I used my pistol to whack as many over the head or in the face as I could. I don't know the number, probably a dozen or so. I do know it was a lot more women than men. The women would not shut up. They wanted to argue and scold us for what we were doing. Besides, they weren't parting with their furs.

How much total cash and loot did you and Duke get from the train heist?
Around $2,000 to $3,000 in cash, a couple dozen rings, watches and necklaces. We had a few furs, too. We were loaded down with all that we could carry. We probably dropped or lost a lot more than that. All our pockets were brimming.

Would Duke have robbed the train if you weren't with him?
No, Duke was my friend and did whatever I asked of him.

When the train robbery was going down, you seemed to want to wear a bunch of different hats. You came onboard with your zoot suit one, you took the porter's cap and finally the engineer's cap. Do you have a thing for hats?
No, I don't have a thing for hats. I was drunk during the robbery and having a little fun. I took the porter's and engineer's to make me look official. They were proud of their hats. I was stripping away their pride.

Tell me about your special-order shoes.
I have big feet. In 1949, I wore a size 13. Stores didn't ordinarily carry that large of a size. I had to special order them. My big shoes were used to help identify me as a train robber when the authorities found them in my suitcase that was left behind. Today, I wear size 14.

What is your IQ? Ever had it measured?
No, but various solicitors put it at 142.

How many times have you been married? How many children?
Five times; the last time I married a black girl. I loved her and didn't care what other people thought. The only child I'll ever talk about is our son we had together, named Rhygia. I'm so proud of him. He's in the air force in Nevada.

Why did you decide to move to and settle in Spartanburg, South Carolina, of all places?
We had saturated the Atlanta, Georgia area with video poker machines and wanted to expand. My "bosses" told me to get in my car and to drive I-85 and to pull off near the intersection of two interstates.

You'd never been to Spartanburg before?
No and had never heard of it either.

You sit on your front porch a lot, don't you?
Yes, I love to watch the squirrels. They do it all—walk, jump, hop, climb and run.

Did you keep up with Duke through the years?
No. (This writer found Duke in Hawaii employed as a ballroom dance instructor and set up a phone call for the two. They spoke for more than an hour, their first communication in more than sixty years.)

Train Bandit Sues B. and O.

Washington, March 18.

A lawyer for one of the two self-confessed train bandits sued the Baltimore & Ohio Railroad today on grounds it brought on the hold-up by serving drinks to a minor.

The minor involved is George L. (Duke) Ashton, now held as one of those who stuck up, wild west style, a B. & O. train near Martinsburg, W. Va., on March 9.

The complaint filed in U. S. district court asked $50,000 for Ashton, who it said is under 21 years old. It said a dining car Steward sold him drinks and then got in an argument with him.

That, the petition said, was the railroad's negligence and was "the motivating force setting in motion the subsequent actions resulting spontaneously thereafter in a train robbery."

The attorney acted in the name of Mrs. Ruth Ungar, of Youngstown, O., mother of Ashton. Ashton and Luman Ramsdell, (32) were captured in Washington the day after the holdup. They told police that the robbery started on the spur of the moment after drinks in the train dining car.

Courtesy of the Martinsburg Journal.

I read in one of the newspaper articles that Duke sued the railroad for serving alcohol to a minor, meaning himself, which contributed to his actions.
Duke's mom did sue them. It got thrown out as frivolous. It was kind of interesting, though, but Duke didn't know she was trying that.

Why do you think you did so little time for such a major offense of robbing and stopping a moving train?
A $10,000 connected attorney who was female. (Lu only served about seven actual years incarcerated.)

She got it arranged only for federal prosecution, correct?
Yes, she got the three states who wanted to try and fry me [Ohio, West Virginia and Florida] *to accept a joint parole deal with the federal prosecution. They couldn't have me after my federal time.*

Did she represent Duke, too?
No, they separated me and Duke.

Were you mafia-protected throughout your life?
I'll let history decide, but I always had friends, influential ones.

Do you have any advice regarding others who may be deciding to take up criminal activities?
From my own personal experience, you learn a lot of crooked things when you hang around crooked people.

Did you forgive the police officer who shot you in the pawnshop?
No, he tried to murder me when I was reaching for an ID that he requested, not my gun.

What about the second time you were shot by police in Atlanta when you were on parole?
I was shot in the back of the leg while fleeing on foot after abandoning my vehicle. I was lucky the officer was a bad shot.

Do you keep yourself armed today in any way?
Yes, at all times I have a small 9mm glock in one sock holster strapped to my leg and a ten-inch knife in my other.

Is your glock registered with the proper authorities?
No.

Has anyone in recent memory ever attacked or bothered you?
No, but I can't take chances.

Do you ever fear for your life?
No, when your number's up, it's up.

Have you ever killed anyone?
No, I have survived on intimidation. Well, yes, if you count all the Japs I shot in World War II.

How many did you shoot and kill?
Too many to count. I don't know. (Lu was wounded in action and received a Purple Heart as a marine on suicide squads in World War II.)

Did you have any heroes as you were growing up?
May sound inappropriate, but it was John Dillinger. I loved gangster movies at the picture show, too.

During your many crimes going back to your youth of robbing grocery stores and stealing cars, what was your most memorable fear?

I feared we had killed three people who we locked in a meat freezer during a Saturday afternoon grocery store robbery in Youngstown, Ohio. We later heard that three people had frozen to death overnight. On further info, it turned out to be three homeless people and not the ones we left locked in the freezer.

What about your innate ability to quickly determine if someone can shoot you? You've told of several instances when you made that decision in quick eye-to-eye contacts. I'm referring to the sheriff's deputy in the diner, also when Duke had a gun in his face when y'all were stealing your second getaway car and one of the officers in the pawnshop shootout.

I survived on intimidation and was never the first one to look away on a stare down. I just have this sense to know if someone can pull a trigger. I know I was lucky. The whiskey gave me brass balls, too. I thought I was invincible.

In the early going before I came to know you better, I thought you were stalking me. You were in the background at my various book signings, speaking events and trivia gigs. That went on for months. My girlfriend thought you were a vampire, always dressed in black and only seen at night. She talked about your piercing eyes and being mysterious. She swore you glided across a room, not really walking. No offense.

I was really casing you out. I wanted someone I could trust to tell my story. I hope you can before I'm dead. I don't want to be forgotten. You have the connections to set the history books straight. I am—Duke, too—America's last moving train robber.

From a newspaper account, it stated that some of your relatives said as a youth you had a steady income from a trust fund well into the thousands, left by your father, who died when you were a child. Tell me about it.

Yea, it was true. I couldn't touch or get at the funds until I reached the age of twenty-five, but I could borrow against it or use it as collateral. I lost $2,000 I borrowed against it when I bought some vending machines. I learned that Hershey chocolate bars do melt in the heat and turn white-colored when old. I did use the trust fund to help with my attorney fees.

So you did robberies and car thefts as a youth, meaning you didn't have that trust fund money coming in, correct?

Yea, that's right. But I had plenty of money coming in from my regular criminal wrongdoings.

Letter addressed from Hemingway to Lu's father. *Courtesy of the author.*

What about your father?
He died when I was two and was well-to-do. There are several buildings at the University of Michigan named in honor of him, who gave them a bunch of money.

What about his connection to Ernest Hemingway?
They were drinking buddies. In fact, my father was in one of Hemingway's weddings and was a member of the wedding party.

Lu, are you a good man who made mistakes?
No, I am not a good man, but age has softened me. There are relatives of many victims who still want me to this day. Spartanburg has always been nice to me. I've reformed.

How would you like to be remembered?
As America's last moving train robber and as an extraordinarily talented artist.

APPENDIX II

Comments from the Community

Asked of those in and around Spartanburg, South Carolina, where Lu spent the last years of his life: What are your thoughts about Lu Ramsdell? How did you come to know him? Was he mysterious? Was he a friend? Was he nice to you? When did you first hear he was a train robber? What was your initial reaction? Anything you want to add about him?

One afternoon [early 2000s], I was finishing up some pre-opening tasks at Bankhead's—a restaurant and bar that Linda, my wife, and I owned and operated—when the door opened, and the absolute embodiment of a southern gentleman walked in. He was a blend of Colonel Sanders and Mark Twain. As it was my pleasant duty to meet, greet and seat everyone who visited our restaurant, I welcomed him in. Within minutes, we had started rattling off our respective résumés, and I found out he had been instrumental in opening the very first discotheque in Atlanta, Georgia. His role had been centered on its marketing and advertising. Within minutes, he had proposed to work with Linda and me to publicize our restaurant, had promised to return soon with some ideas, had finished his drink and had departed as quickly as he had arrived. That was my first meeting with Lu. In just a couple of days, Lu reappeared at the restaurant with a sheath of papers and notes. He had virtually redesigned our menu and had the finished artwork of a proposed logo for our restaurant. We liked what we saw and immediately agreed to be one of his clients, beginning a working relationship that lasted off and on for several years. Then, one day, Lu disappeared as mysteriously as he had arrived, leaving only our pelican logo behind as proof that he

Bankhead's
Grilled Seafood & Steaks

Linda & Tony Brooks
Welcome you to Bankhead's

Home of the Best Grilled
Seafood & Steak in town...

Where the conversations
sparkle and cocktails
flow...and

Where the evening often ends
with plans being made
to come back soon

Bankhead's logo, designed by Lu. *Courtesy of the author.*

had been a talented contributor to our success. It was years later when I encountered Wilson Casey and asked him, 'What are you working on,' that he told me he was writing about the last moving train robbery in the United States—a fascinating caper committed by a man named Lu Ramsdell...It took a moment to realize, and longer than that to comprehend, that our logo drawing ad-man and Wilson's train robbing bad-man was the same person."

—Tony Brooks, acquaintance,
retired restaurant owner,
Spartanburg, South Carolina

"Lou was quite a memorable character. One of the few you will meet in your life. He would talk openly about some things and avoid others. We were sitting in a restaurant one night about 9:00 p.m. playing trivia. He had told me some of his background, and I had gotten at ease around him. In the middle of one of his stories, a rather large man rudely bumped his chair. Lou shot him a look that chilled the room by ten degrees. When the man saw this, his eyes widened, his face went pale and he most humbly apologized for the interruption. Scared me. It was like this kindly gentleman had reverted back in time to the 1940s and his criminal persona. Within minutes, though, everything was back to normal, but I will never forget that look. After his stroke, I visited him in the nursing home. They had cut his magnificent beard. He spoke softer, and the old spark was gone. I will miss him and am glad to have been his friend. RIP, Lou."

—S. Deane Brown, friend, retired teacher,
Spartanburg, South Carolina

"Met Lu at Basil's Grille playing trivia with him. He was a mysterious man, only told you what he wanted you to know. I liked the man, enjoyed his company. So interesting hearing his story."

—Phil Cannon, friend, tavern owner,
Boiling Springs, South Carolina

"I came to play trivia at one of dad's gigs one night. I was sitting at a table for about an hour when I noticed a mysterious-looking older gentleman sitting at the end of the bar by himself. His attire didn't look like the normal attire of the men there. He had on a long black leather trench coat with his face sporting long white hair and beard. He never looked up but hovered over his drink at the bar the whole time. He didn't seem engaged in the trivia or even interested at all. I went back to the trivia but, at the same time, kept looking out the corner of my eye at the mysterious man. I'm not sure why, but I was waiting to see what he'd do or what he was about. Next thing I know, my dad is telling me he wants to introduce me to a friend of his. Lo and behold, it's the mystery man! I was a little nervous as I got up from my seat and headed to the corner spot of the bar where he was. He didn't move or look up from his drink until my dad and I were right up on him. My dad says, 'Lu, this is my daughter, Colleen.' He turned, nodded his head and we shook hands. I was raised to be polite and to strike up small-talk conversation when introduced to someone new. So, of course I said hello, asked how he was doing, was he enjoying the trivia, that it is was nice to meet him, etc. His responses were one-word answers, very short. I felt like I was intruding, so I backed away and went back to my seat. I mean, he was nice but odd. That was my one and only encounter of the train robber, though it was a simple meet that day. It sticks out in my mind, and I'll never forget him. Something about him left an impression on me still to this day. Rest in peace, Lu."

—Colleen Casey, acquaintance, Spartanburg, South Carolina

"The first time I met Lu, he was at a trivia party at a local bar/restaurant. My first impression was that he was out of place, with his scraggly beard and baggy clothes and very mysterious. He soon proved his intelligence by winning some trivia rounds or games. However, when introduced, I had very bad vibes, the scary kind (which I have learned to listen to). He was never disrespectful in any way and was actually very respectful and gracious. When Wilson began interviewing Lu for the book, I suggested for him to meet Lu somewhere other than home. Maybe I was wrong in my request, maybe not. After reading this book, would you let that character come into your home?"

—Connie Hollar, acquaintance, RN, Mooresboro, North Carolina

"I met Lu several years ago playing trivia. We were partners on many occasions. Lu was very smart (that is why he was my partner), and he was

funny. We always had a great time just chatting. I will not forget the memories made! RIP Lu!"

—Kelli Cannon Lanford, acquaintance, trivia playing partner,
Boiling Springs, South Carolina

"When I first moved into my house, Lu was living next door. We spoke when I'd come in and go out because he spent a lot of time sitting on his front porch. I would tell my friends that I was living beside the world's oldest hippie because he had long gray hair and a long gray beard with original art hanging on the porch. A very interesting hippie.

Lu learned that I worked for the *Herald-Journal* and said he wanted somebody to write his story about how art had saved him. In addition to my real job, I was teaching a course at Gardner-Webb University and was undergoing cancer treatment, so I didn't have the time or energy to help him, but he talked to me about his life. He told me that he was a bad man when he was young. He didn't really care about anything but about how discovering art while in prison saved his life, gave him purpose and changed him into a better person.

One thing he told me was not about himself but about his parents. His father was an ambulance driver during World War I in Europe with Ernest Hemmingway. His father was a member of Hemmingway's wedding party when he married Hadley Richardson, the first of the writer's wives.

The two remained friends, and when Hemmingway wrote *A Farewell to Arms*, he sent Lu's father a signed copy. Lu's mother didn't like the book, and Lu said she gave it away.

I found Lu to be a good neighbor. Sometimes I would cut the grass in his front yard for him, and he would give me money to feed the cats that gathered at my house when our neighbors would adopt them and then not take care of them. Lu liked to watch them play in my yard—until they got under his house and tore up the insulation.

He also liked to watch the squirrels. There was a red squirrel among the gray ones, and he delighted in following its progress through the giant oaks in our front yards. There is still a red squirrel there today."

—Ann Patterson, next-door neighbor, copy editor at *Herald-Journal*,
Spartanburg, South Carolina

"I first met Lu when he came to the real estate agency in 2007 where I worked, and I was assigned to get him info he wanted. He was approximately eighty-one years old. I later met him at a trivia match led by Wilson Casey

at Bankhead's restaurant several years later. His eccentric appearance—the long white Santa Claus beard and long white hair—made him stand out. But he was not unfriendly, so I got to know him. We had brief conversations at weekly trivia matches. We talked about his nightclub background in Atlanta and his advertising business. He did not mention the train robbery until I'd known him for approximately two years. He gave me no indication of his criminal past before or after the train robbery. Knowing the robbery was many years ago (sixty-plus) and figuring he had paid his debt to society, I did not give it a lot of thought after the initial shock. But he was not someone I'd want for a stockbroker or business partner."

—Bruton Redding, friend, retired business owner,
Spartanburg, South Carolina

"The Spartanburg Stamp Club held monthly stamp club meetings at the Woodland Heights Recreation Center. Lu Ramsdell joined the club in the early 2000s and was a faithful member and stamp collector. I only knew that he was from Atlanta. He came to the meetings for many years until his health declined. Lu had a very long beard and drove an older-model car. He was very creative in various design drawings, as I had seen a lot of things he had done. He was instrumental in the stamp club's logo. Each year, we had a Christmas get together at a member's house, and Lu came along, usually with a lady friend. I think she did the driving. Never did I think Lu had a notorious past as a train robber. Lu was nice to everyone. I believe he was trying to do the right thing at this point in his life. I only saw him at the meetings. He, of course, collected stamps. His primary interest was in airmail [stamps]. I treated him just like I would any other member of the club. I knew very little about him in the ten years he was stamp club member. We got along very well."

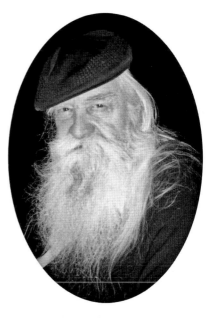

—Bob Sutherland, acquaintance,
Reidville, South Carolina

Lu was a nice guy in later years. *Photo by S. Deane Brown.*

135

"I knew Lu very well. He really became a dear friend to me, and I was with him through all the rough times and held his hand in the end. Yes, he was indeed a very good friend who I loved like my grandfather. He spent many a holiday with me and my family, and when he passed, it was a sad event for us all. My grandchildren still talk about how he would bring paint and papers and teach them to paint...he was for sure an artist, and he loved to show the kids. I would say Luman Ramsdell was a good man who had strayed from the right road but in the end made an awesome life for himself. I am truly grateful I spent time on his journey with him and so blessed that he gave myself, my children and my grandchildren a grandfather. We were Lu's 'family' and miss him everyday."

—Patty Wright, friend, professional photographer,
Spartanburg, South Carolina

APPENDIX III

Miscellaneous Lu

A letter to the editor of the Spartanburg Herald-Journal *in May 2010 by Luman Ramsdell.*

WHO NEEDS REHABILITATION?

The majority of all convicted criminals are released. Ex-convicts offer to buy your daughter drinks in bars and dance with them! Ex-convicts jog along side your brother. Ex-convicts carry your grandmother's groceries to the car and ex-convicts may be working for a exterminator spraying every nook and cranny of your home! Ex-convicts are accountants, truck drivers, cooks, taxi drivers, hairdressers, salesmen and yes, ex-convicts are unemployed, ex-convicts are dopers and drunkards. Ex-convicts snatch purses, rob homes, rape, plunder, and murder.

Millions of men and women are so offensive to society that they are put in jails, reformatories and prison so we can release another million ex-convicts. Think of it this way. Every time we put a murderer in jail, we release one. Every time we put a child molester in jail, we release one. Do you understand that [even with] the one, two, five, ten, or twenty years we confine a person in prison that someday HE/SHE WILL BE RELEASED?

The model prisoner, the well-behaved prisoner, will be released under supervision or parole. The vicious prisoner, the unrepentant, the hostile prisoner will be released under absolutely no supervision or parole because he could not be good enough for parole consideration or his "good time" was taken from him for prison infractions.

APPENDIX III

Ramsdell Graphics & Advertising

dba

Give me 15 Minutes and I'll give you

$100 Cash...

Care to try a good idea rather than a heap of money to increase sales?

The creative talents of Lu. *Courtesy of the author.*

He's released without funds, friends, or worldly possessions. He is now an Ex-Convict and he is yours! The beatings by guards, the humiliation and degrading of months or years is over. The filth, the cockroaches, the surly guard [with the] tobacco stained beard no longer spits on him. The days of dampness, un-comfort, bed-less boredom in "the hole" are over. The howling empty stomach no longer causes his teeth to grind. OK he is released and he is yours. He is an ex-convict, and he is in your community.

When you come home your TV is gone, your recorder, your silverware, money, or home computer. Do you ever think that the thief is an ex-convict and was not rehabilitated? Of course not. Revenge! Call the cops. Report the secret mark you put on everything and hope they catch the bastard. Then wait. Wait till they catch him and prosecute him again. Remember one thing though, as his lowered head and handcuffed scarred wrists are released from prison: another gnarled, ill-clothed Ex-Convict gives him a sidewise glance and a mischievous wink as he puts his foot in freedom. Think about it. Would you want him back bitter, unrepentant, vicious and hateful…or would you prefer him rehabilitated?

More creative talents. *Courtesy of the author.*

I

This book is the astonishing true story of America's Last Train Robber and his incredible rehabilitation. Headlines thruout America proclaimed, "Two Train Robbers taken in Gun Fight; One Shot By Washington Police Officers". Luman C. Ramsdell, a 23 year old former U.S. Marine with a 50% combat related disability & George Llewellyn Ashton 2D confessed to the daring holdup of the crack B & O's Ambassador. Ramsdell sentenced to two twenty year terms in a Federal Penitentiary with additional "Holders" to be tried in 3 states upon completion of the Federal sentence. Ohio 20 year parole violation

2

W. Virginia, numerous armed robbery charges possible penalty. electric chair or life – Florida numerous armed robberies possible penalty electric chair or life. When asked when he could be released he was told NEVER! Confined in the U.S. maximum security prison in Atlanta, Ga. his life changed. Within 10 years he not only was paroled, charges droped by the 3 states, he was the head of his own Advertising Agency advising multi-millionaires like Tom Cousins how to sell family homes! He then invented a new type nite club called a discotest. This club was franchised & changed the nite life habits of millions of Americans. Stories include

3

such national known celebrities as Jay Leno, Pat Paulson, Ted Turner, Tom Cousins, Walter Winchel, Joe Boone, (atlanta street named after) John O. Boone, Corrections Director, Mass., Gen. Mitch Werbell, Andrew Young

Lu's own handwriting. *Courtesy of the author.*

Sources

Interviews and Conversations

Brown, Mr. S. Deane, Spartanburg friend of Lu.
Cooperman, Mr. Gerald, newspaper researcher.
Maranto, Mr. John, B&O Museum, Baltimore, Maryland.
McPherson, Mr. Ryan, B&O Museum, Baltimore, Maryland.
Ramsdell, Mr. Luman, head bandit and train robber, about himself, "Duke" Ashton and Ms. Roberta Haus.

Organizations and Periodicals

Appalachian History. www.appalachianhistory.net.
Associated Press.
Atlanta Journal-Constitution (GA).
Baltimore & Ohio Magazine (MD).
Baltimore Morning Sun (MD).
Baltimore News Post (MD).
B&O Railroad Museum, Baltimore, Maryland.
Berkeley County Historical Society, West Virginia.
Boston Herald (MA).

Chicago Tribune (IL).
Cleveland Plain Dealer (OH).
Detroit Free Press (MI).
Federal Bureau of Investigation, Washington, D.C.
Hays T. Watkins Research Library, Baltimore, Maryland.
Headline Comics (NY).
Library of Congress, Washington, D.C.
Los Angeles Times (CA).
Martinsburg Journal (WV).
Metropolitan Police Department, Washington, D.C.
New York Times (NY).
Philadelphia Inquirer (PA).
Port Huron Times Herald (MI).
Richmond Times-Dispatch (VA).
Spartanburg County Public Library, Spartanburg, South Carolina.
Spartanburg Herald-Journal (SC).
Spartanburg Journal (SC).
Trivia Guy—Expert Wilson Casey. www.triviaguy.com.
United Press International (UPI).
Washington Post (D.C.).
Washington Times Herald (IN).
Wikipedia. www.wikipedia.org.

To any/all others inadvertently omitted, a sincere thanks.

About the Author

Wilson Casey (aka the Trivia Guy) is one of the country's foremost trivia aficionados, with a syndicated newspaper column (more than five hundred papers), an award-winning website and a place in the *Guinness Book of World Records* for the longest-running radio trivia marathon broadcast in which he correctly identified the correct answers to 3,333 consecutive questions during a nonstop thirty-hour period. His various array of published works of

The author with Lu. *Photo by S. Deane Brown.*

books and daily box calendars run the gamut of appeal, from "Bible" to "Cigar Diet" to "Golf" to "Firsts" to "Know It or Not" to "True Crime" to "UFO" and everything in between. When not out speaking, promoting, emceeing and entertaining, he lives in Spartanburg, South Carolina, and is an avid tennis player. Feel free to e-mail him at wc@triviaguy.com or visit his website (triviaguy.com).